DRAWING AND CARTOONING
ALL-STAR SPORTS

DRAWING AND CARTOONING
ALL-STAR SPORTS

A STEP-BY-STEP GUIDE FOR THE ASPIRING SPORTS ARTIST

TONY TALLARICO

A Perigee Book

A Perigee Book
Published by The Berkley Publishing Group
A member of Penguin Putnam Inc.
200 Madison Avenue
New York, NY 10016

First edition: July 1998

Published simultaneously in Canada.

The Penguin Putnam Inc. World Wide Web site address is
http://www.penguinputnam.com

Library of Congress Cataloging-in-Publication Data

Tallarico, Tony.
 Drawing and cartooning all-star sports: a step-by-step guide for
the aspiring sports artist / Tony Tallarico. —1st ed.
 p. cm.
 "A Perigee book."
 ISBN 0-399-52417-7
 1. Sports in art. 2. Drawing—Technique. 3. Cartooning —Technique. I. Title
NC825.S62T34 1998
743'.8796—dc21

 97-41548
 CIP

Printed in the United States of America

10 9 8 7 6 5 4 3 2 1

FOOTBALL

By following the simple shapes, as shown on the next
page, you can draw this ALL-STAR player.
NEVER put details into your drawing before you've
completed the basic shapes lightly in pencil.

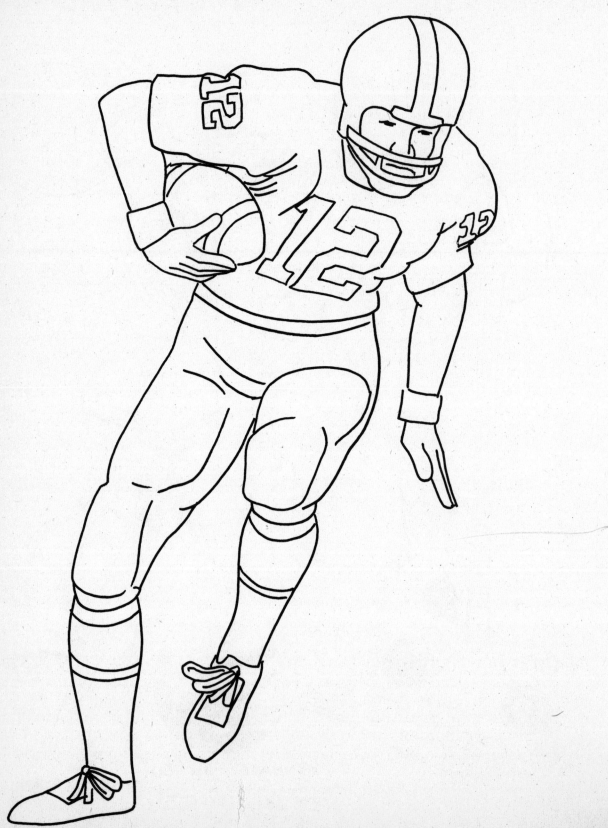

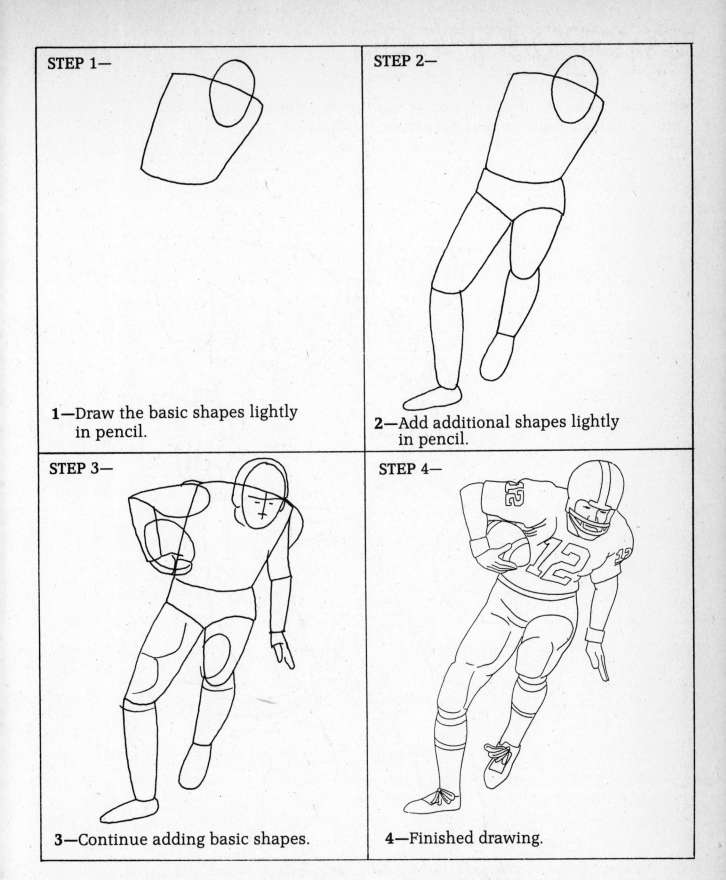

STEP 1—

1—Draw the basic shapes lightly in pencil.

STEP 2—

2—Add additional shapes lightly in pencil.

STEP 3—

3—Continue adding basic shapes.

STEP 4—

4—Finished drawing.

Always draw the first three steps lightly in pencil. Don't be afraid to draw through sections of the picture. When you are happy with the basic shapes you've drawn, complete the picture using a felt-tip pen. Erase all the pencil lines.

BASKETBALL

Follow the steps on the next page to draw this ALL-STAR player. At this point just concentrate on doing a simple line drawing.

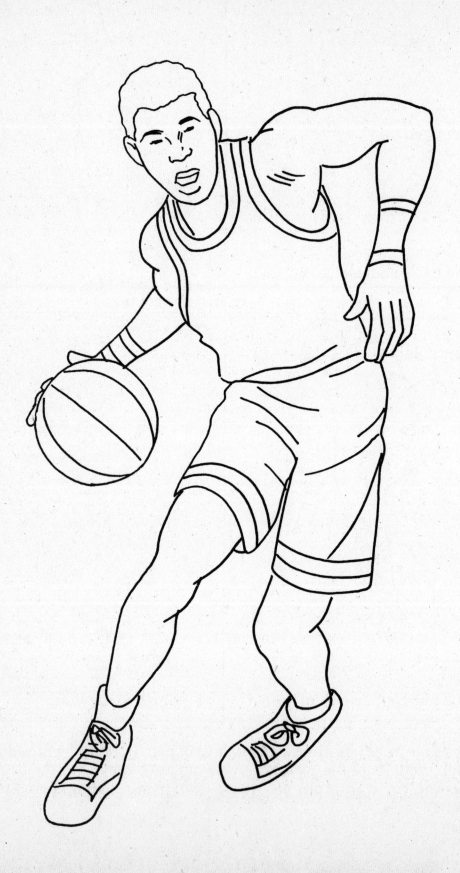

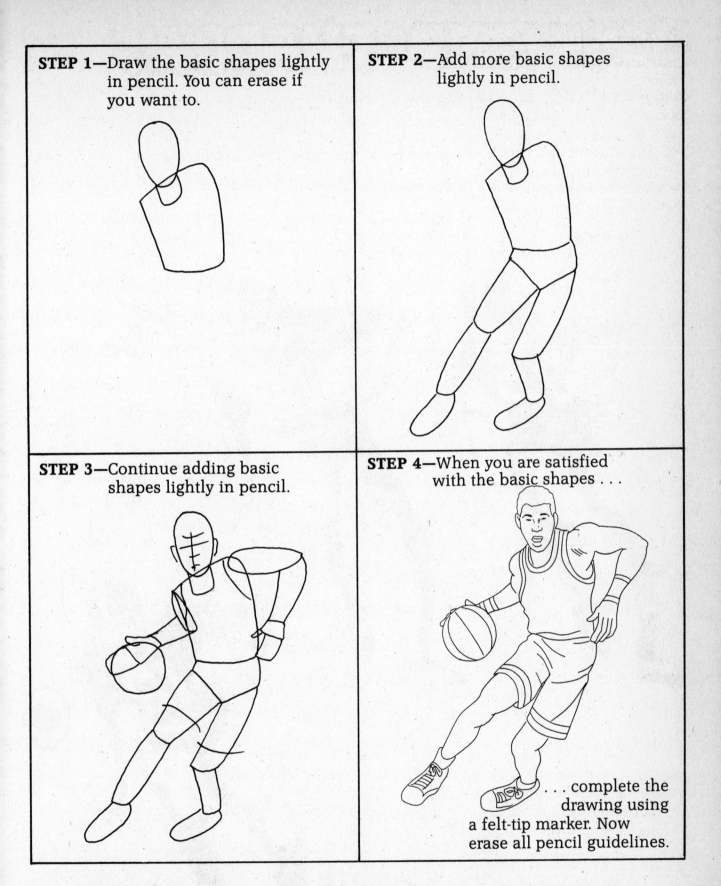

STEP 1—Draw the basic shapes lightly in pencil. You can erase if you want to.

STEP 2—Add more basic shapes lightly in pencil.

STEP 3—Continue adding basic shapes lightly in pencil.

STEP 4—When you are satisfied with the basic shapes . . .

. . . complete the drawing using a felt-tip marker. Now erase all pencil guidelines.

Details should be drawn only after all the basic shapes have been drawn to your satisfaction. A complete foul is when a good detail is drawn on a poor shape. Now let's light up these drawings . . .

LIGHT AND SHADOWS

Shadows add a new dimension to any drawing.
Follow these simple steps:

1—Establish a light source.
2—Using a number 2 brush and black india ink—or a black marker—put shadows and blacks in.
3—Wherever light strikes the figure, leave white. Be aware of cast shadows.

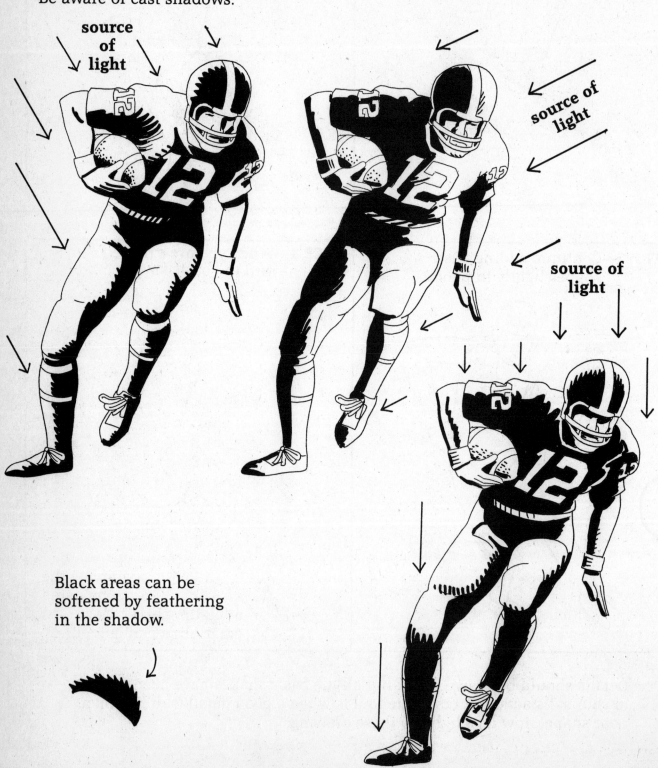

source of light

source of light

source of light

Black areas can be softened by feathering in the shadow.

8

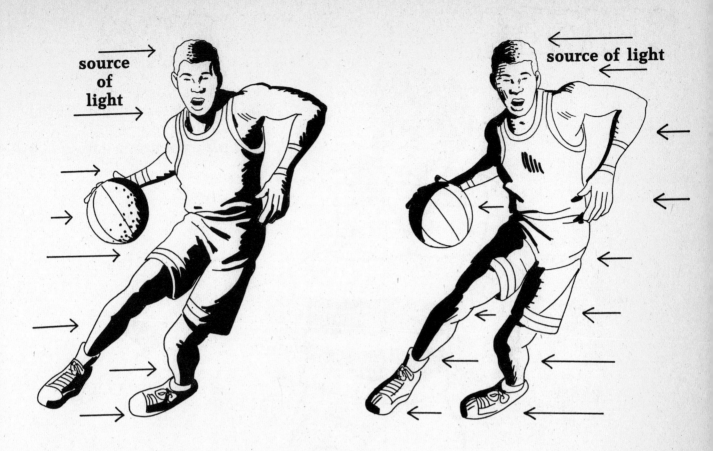

Notice how each drawing changes because of the light source.

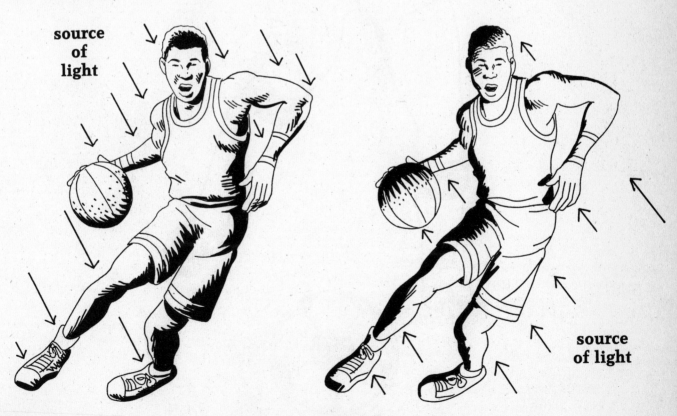

Go back and put light sources on the previous pages.

SOCCER

Decorative black areas, also known as "local color," can be used instead of shadows from a light source to complete your drawing.

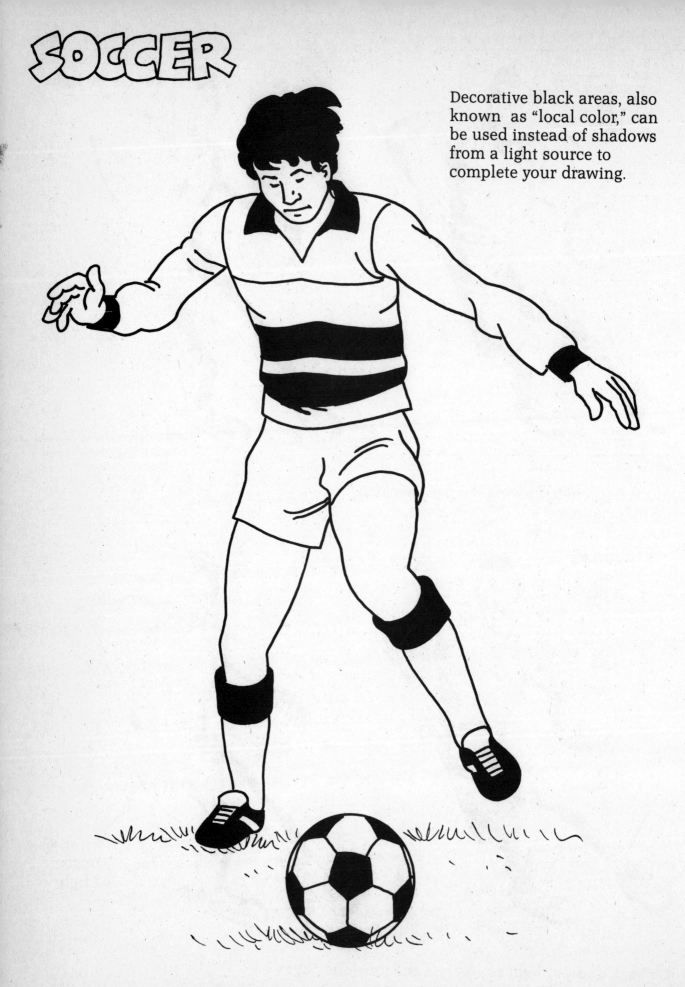

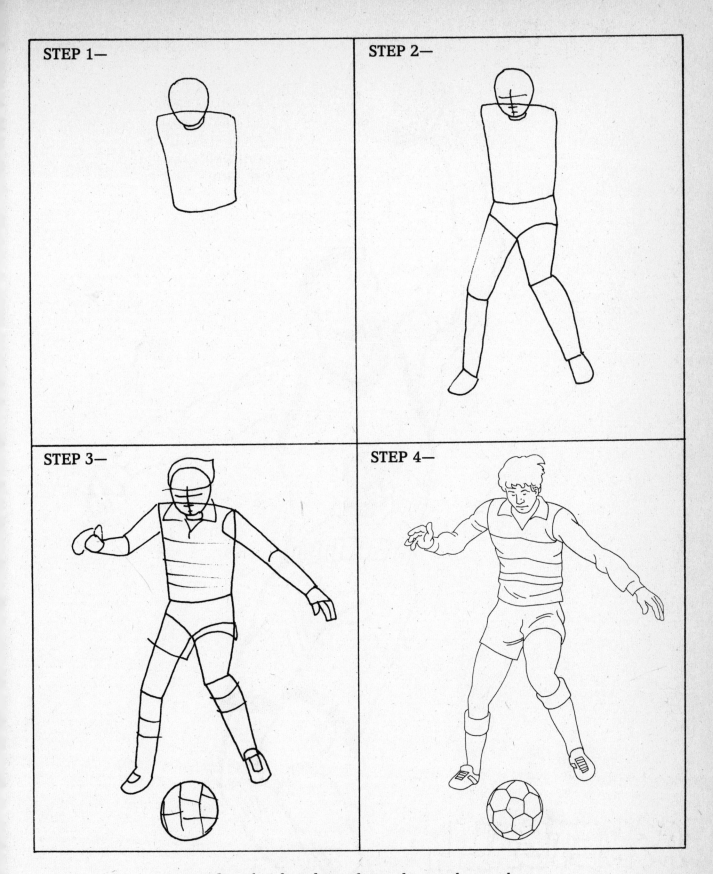

STEP 1—

STEP 2—

STEP 3—

STEP 4—

Don't be afraid to draw through your basic shapes
to make sure shapes are placed in proper areas.
Draw the first three steps lightly in pencil.

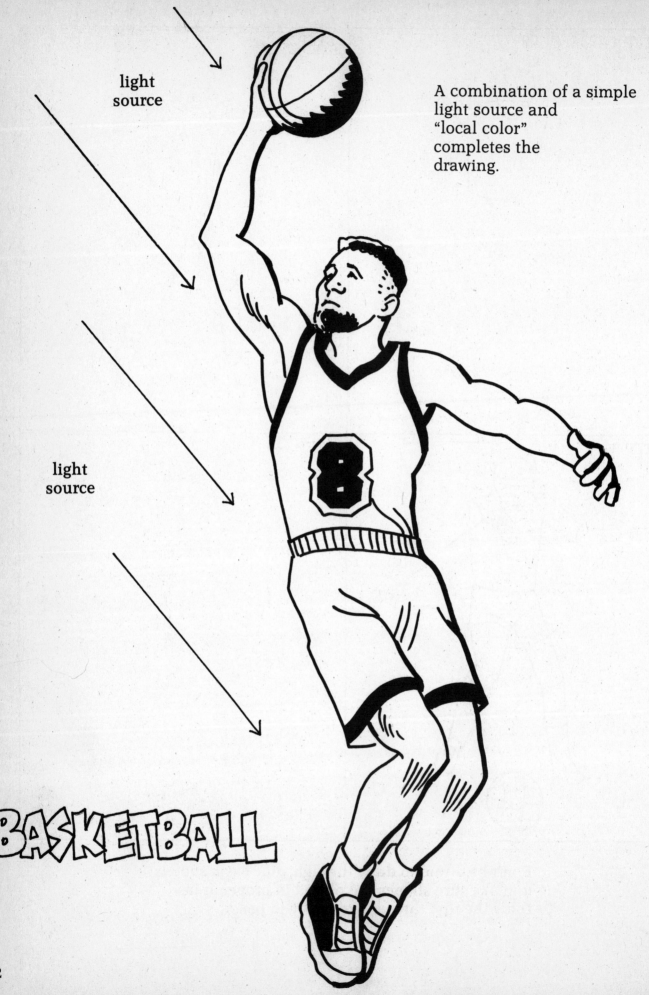

light
source

light
source

A combination of a simple
light source and
"local color"
completes the
drawing.

BASKETBALL

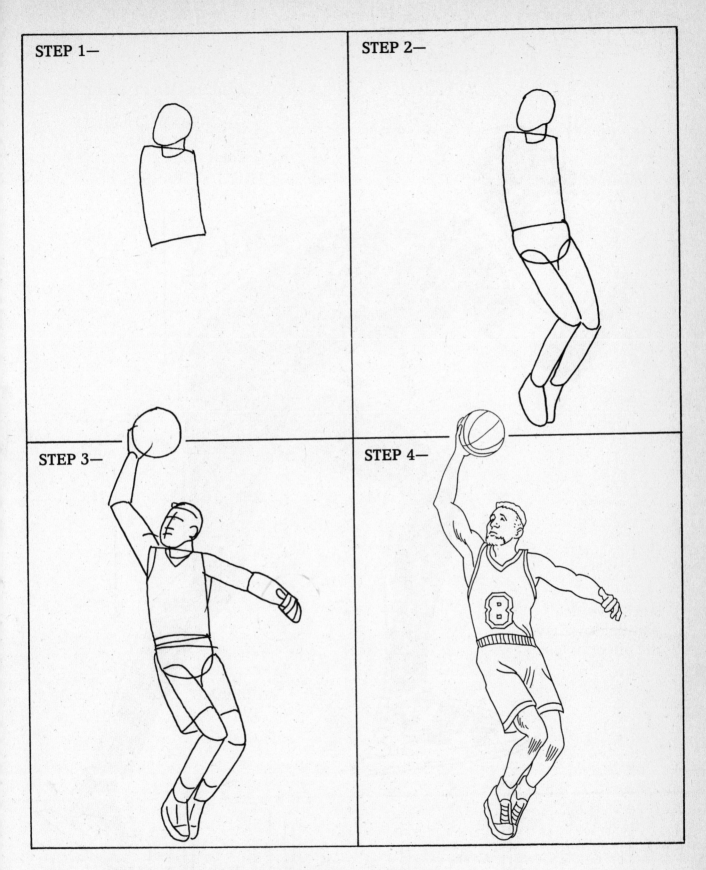

STEP 1—

STEP 2—

STEP 3—

STEP 4—

Draw the basic shapes lightly in pencil, and
DON'T BE AFRAID TO ERASE!
Well-drawn basic shapes will make your completed picture look good.

SPEED SKATING

A simple overhead light source has been used.

Simple vertical parallel lines give the effect of ice.

14

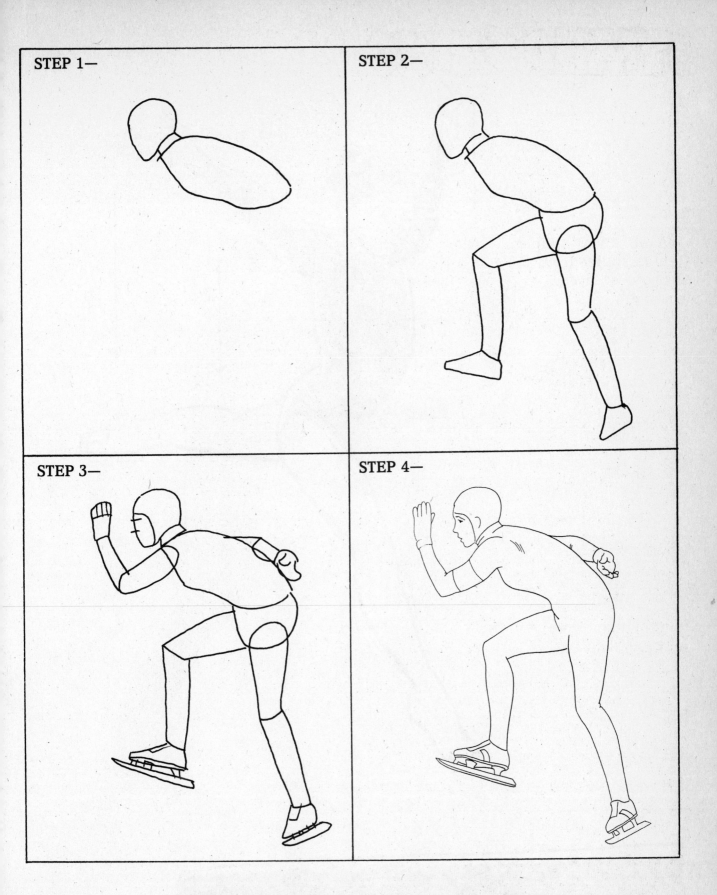

STEP 1—

STEP 2—

STEP 3—

STEP 4—

Although the final art is almost a silhouette,
you still need to draw all the steps correctly.
Try using your own light source.

GYMNASTICS

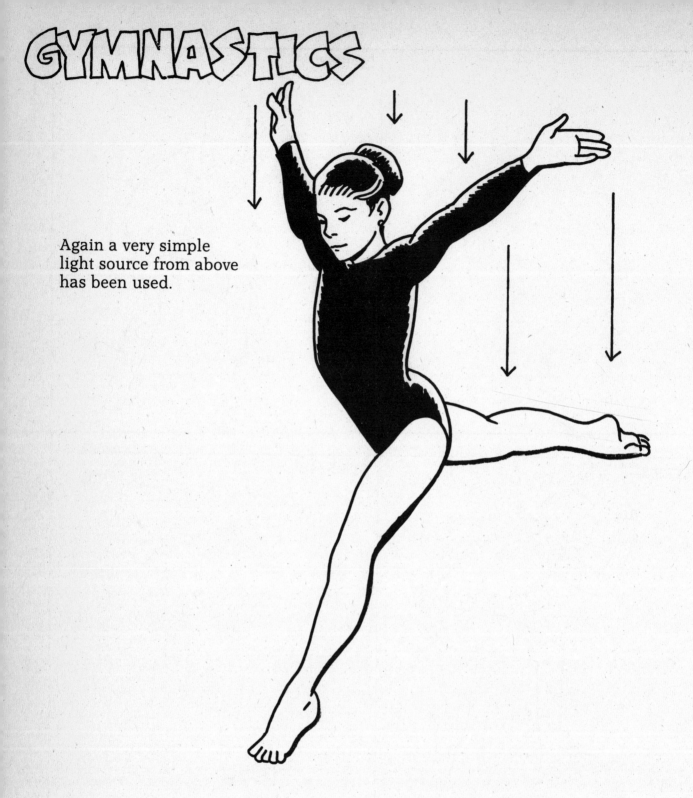

Again a very simple light source from above has been used.

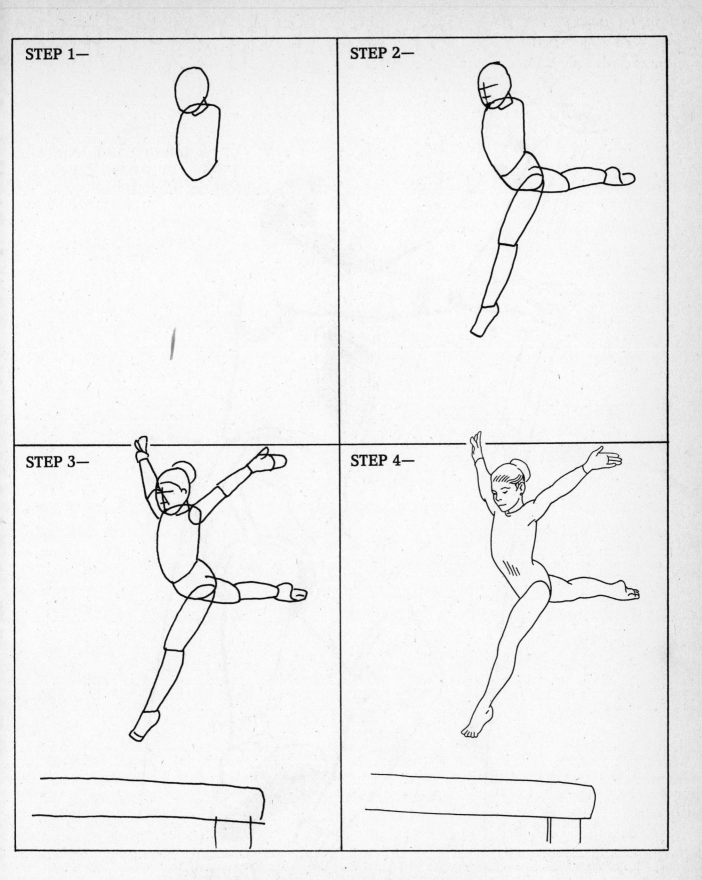

STEP 1—

STEP 2—

STEP 3—

STEP 4—

Draw the basic shapes correctly and all the
other details and shadows will fall into place.

2 POINT SHOT

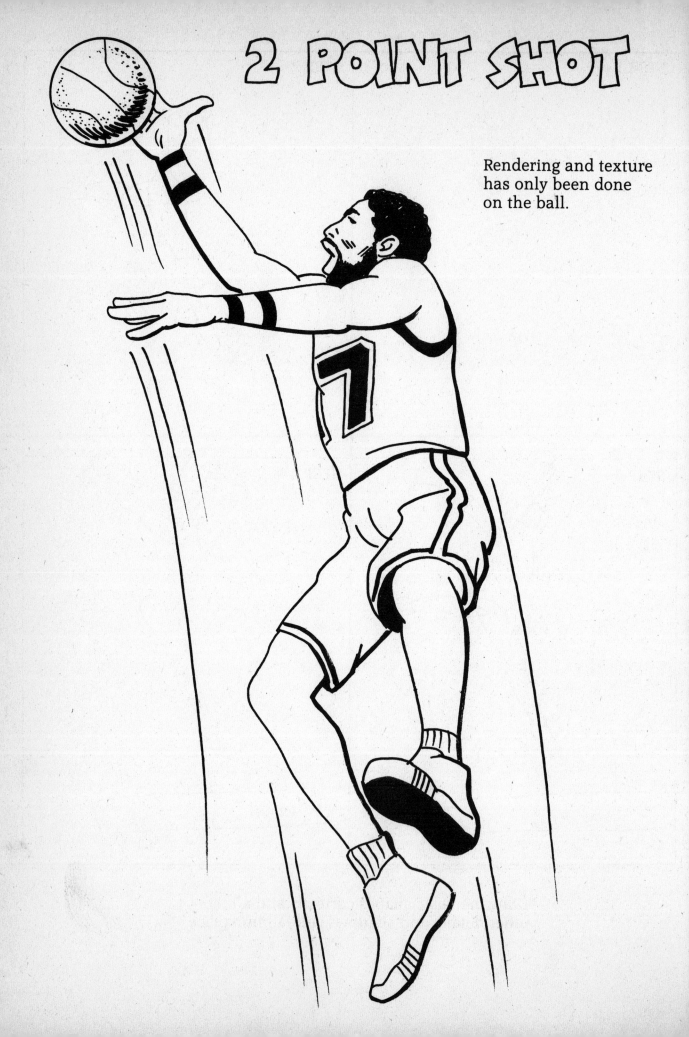

Rendering and texture has only been done on the ball.

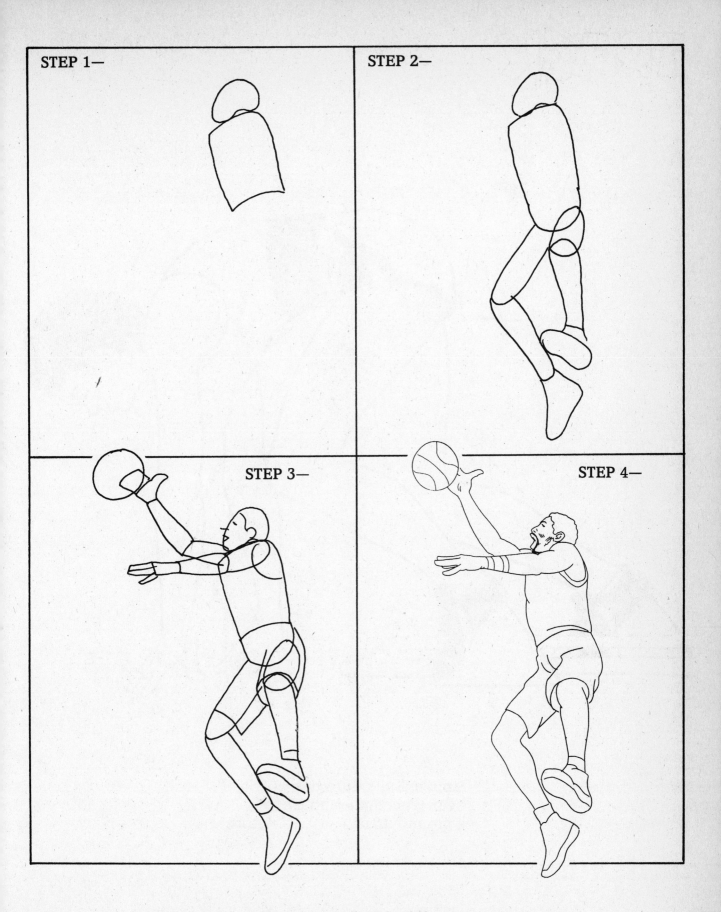

STEP 1—

STEP 2—

STEP 3—

STEP 4—

Action lines will give your finished drawing movement.

TRACK

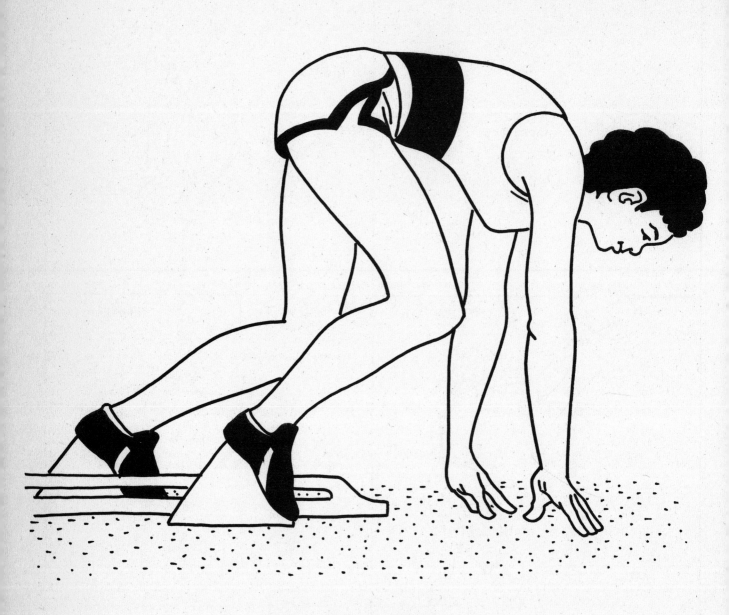

Simple dot-texture has
been placed to establish
a ground area.

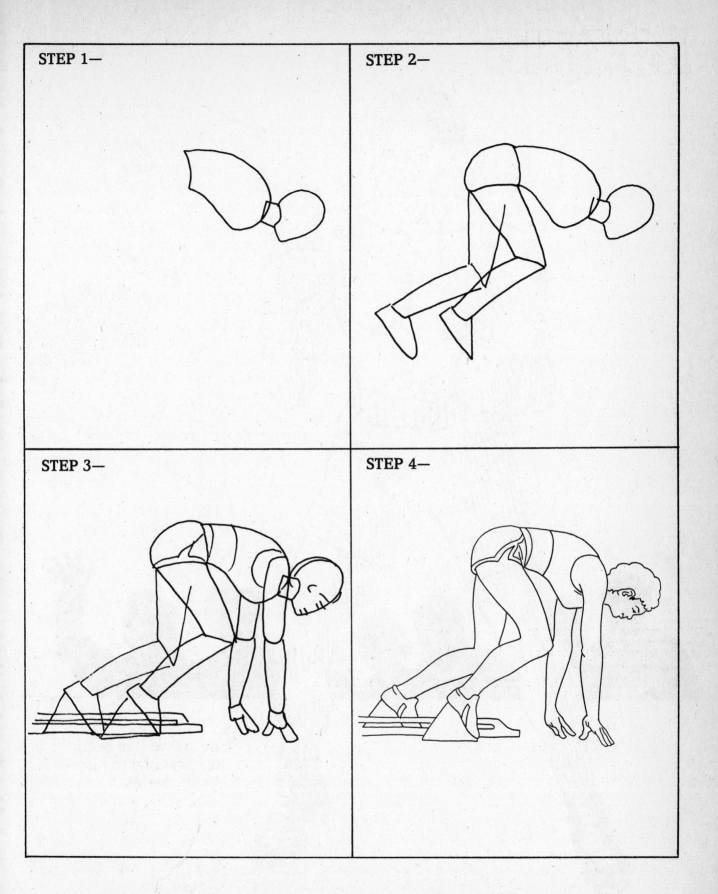

STEP 1—

STEP 2—

STEP 3—

STEP 4—

Keep the black areas simple so as not to interfere with the action of the figure. No shadows or a source of light have been used.

BOXING

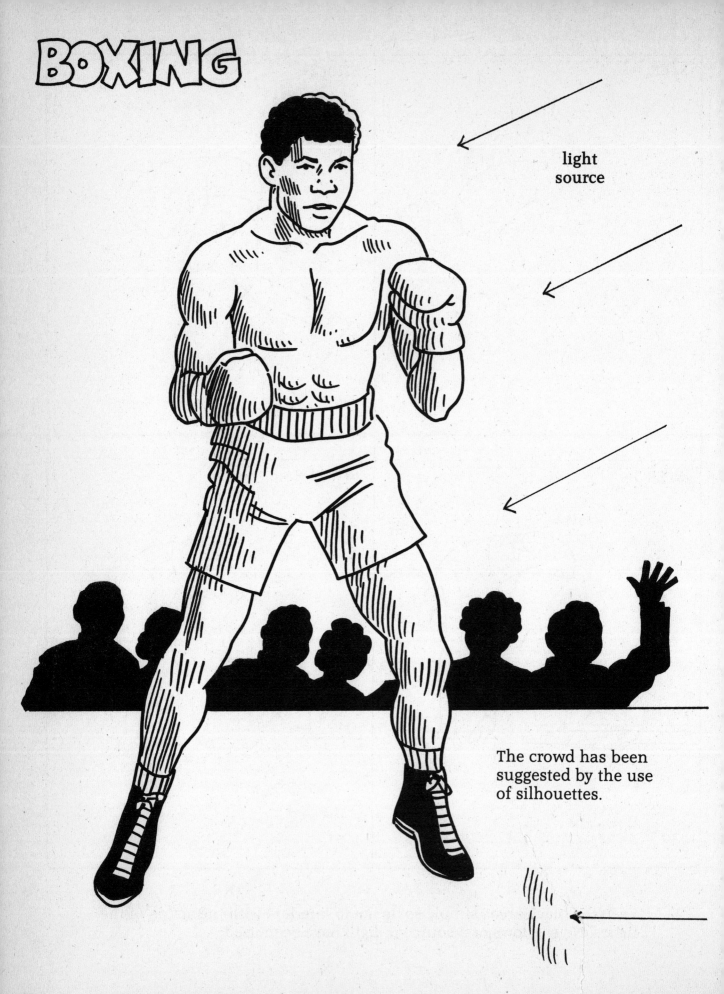

light
source

The crowd has been
suggested by the use
of silhouettes.

22

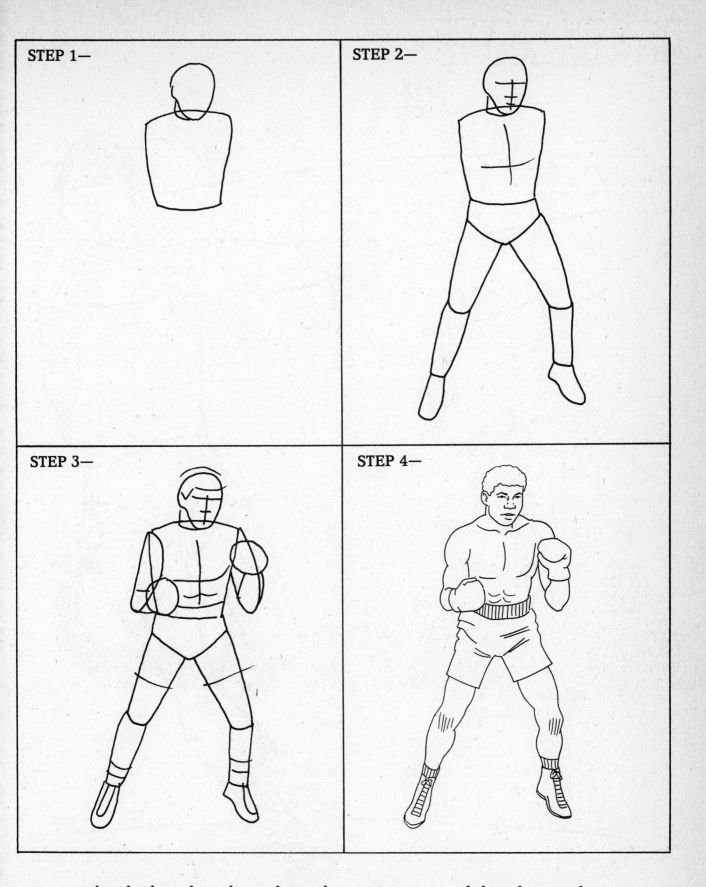

STEP 1—

STEP 2—

STEP 3—

STEP 4—

The shadows have been drawn by using a series of short line strokes.
Solid blacks have been spotted in a decorative manner.

HAMMER

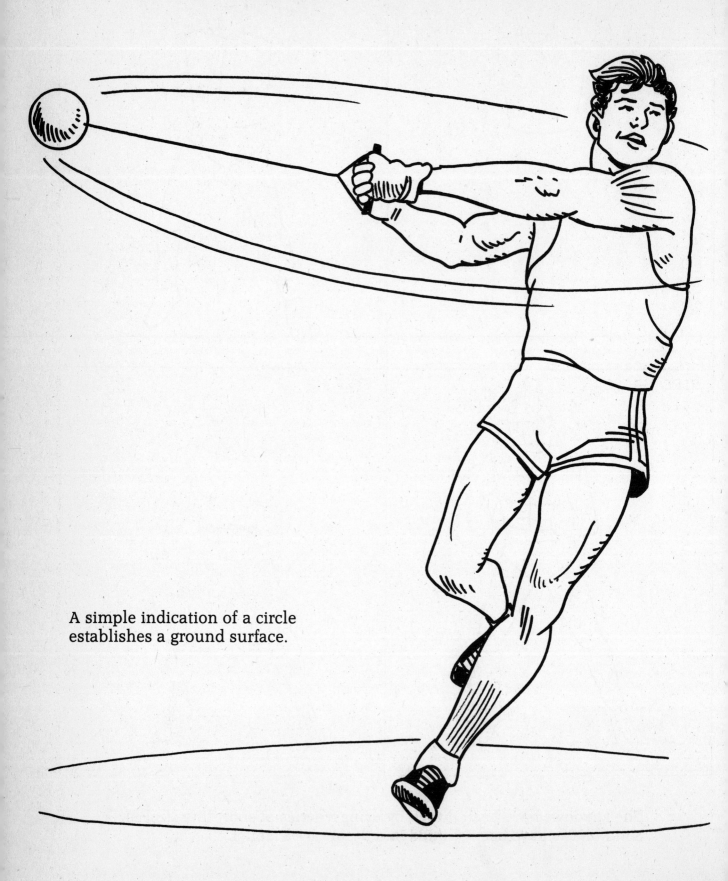

A simple indication of a circle
establishes a ground surface.

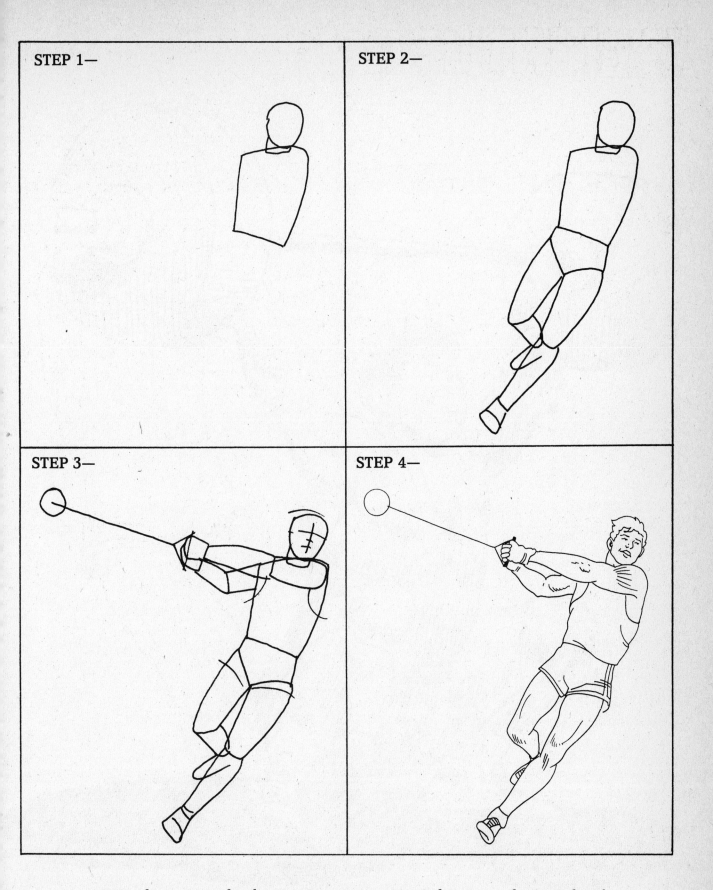

STEP 1—

STEP 2—

STEP 3—

STEP 4—

Action lines give the figure movement. Draw the action lines only after you've completed the drawing of the figure.

WEIGHTLIFTING

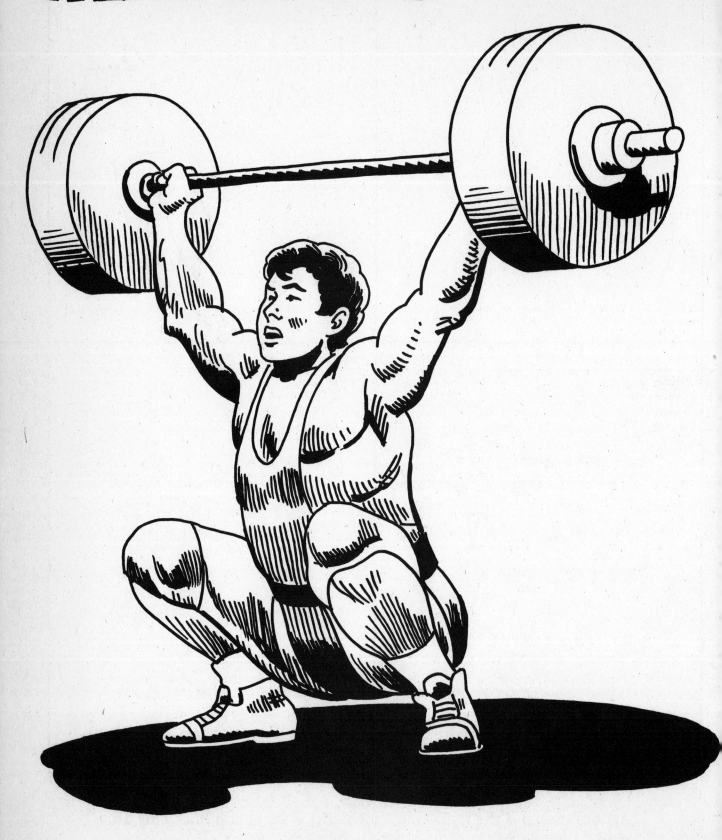

The overhead lighting helps to
add weight to the drawing.

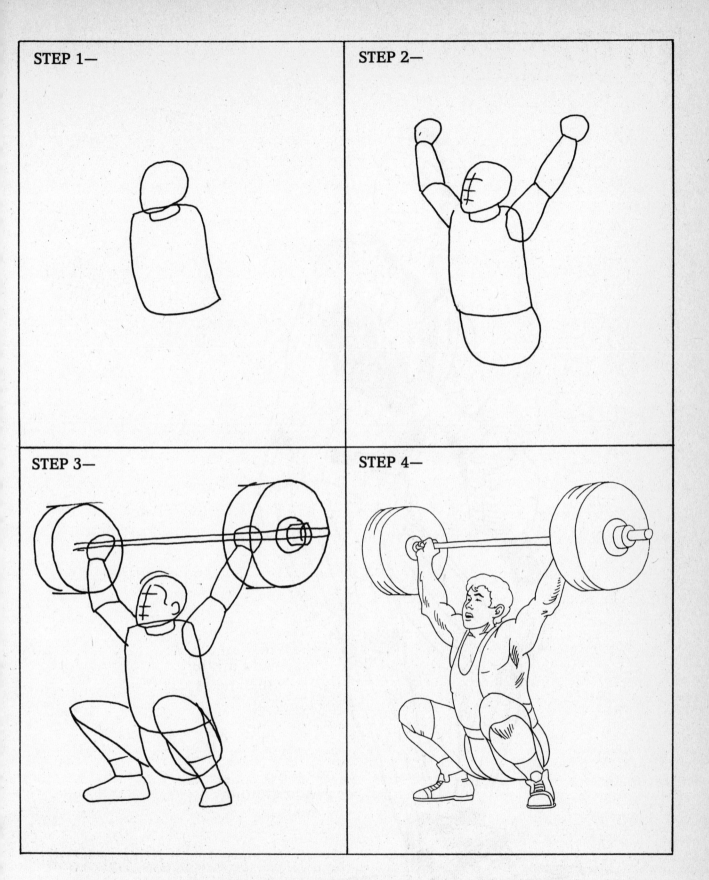

STEP 1—

STEP 2—

STEP 3—

STEP 4—

Draw the basic shapes of the entire figure before drawing the shapes of the weight. Even though you do not see the left hand and part of the arm, you must still draw these basic shapes to know where to place the weights.

PITCHER

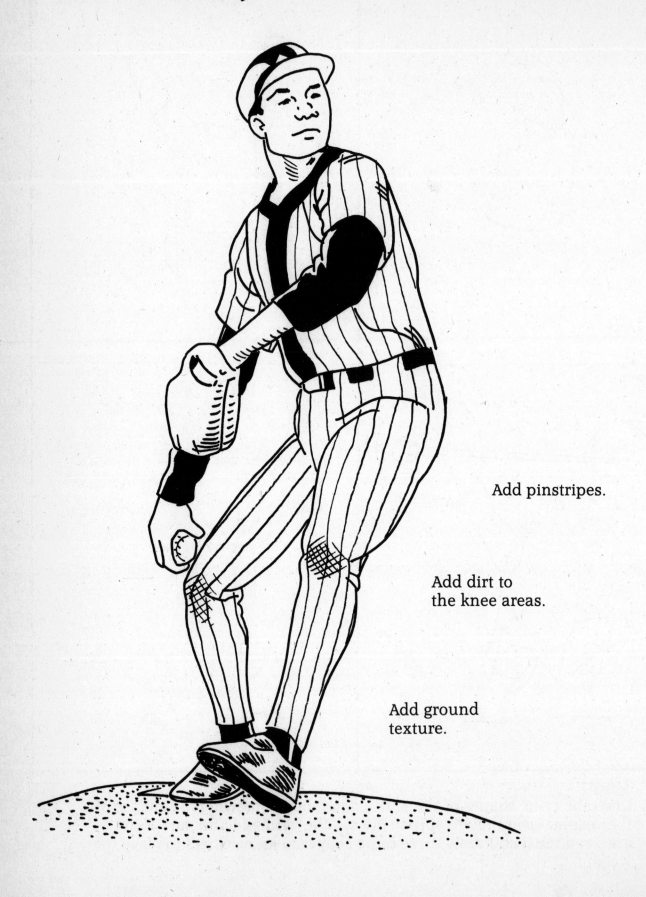

Add pinstripes.

Add dirt to
the knee areas.

Add ground
texture.

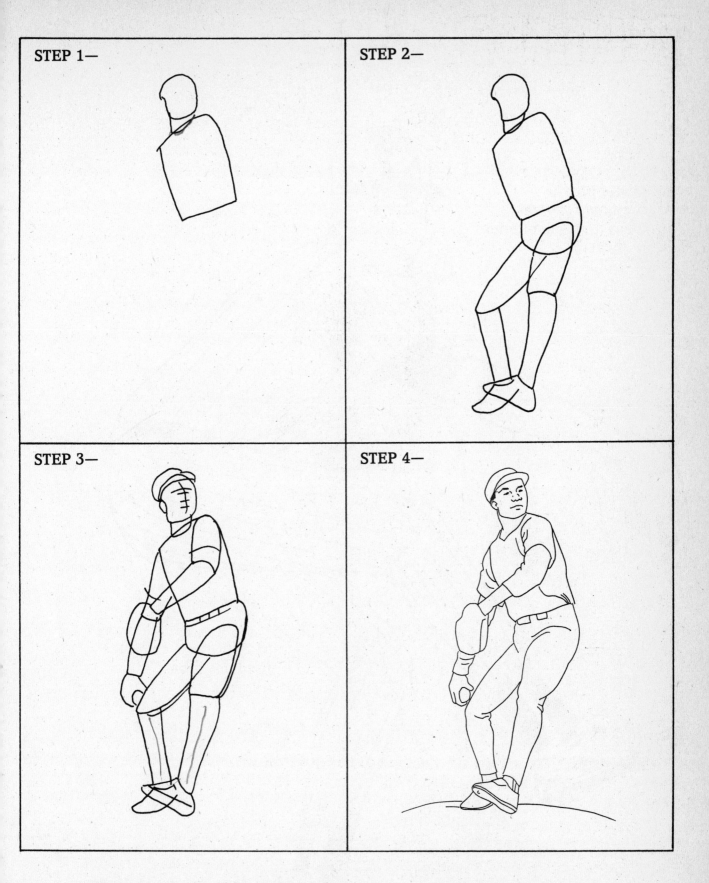

STEP 1—

STEP 2—

STEP 3—

STEP 4—

Keep drawing the first three steps lightly in pencil. Complete your drawing only when you are happy with the basic shapes you've done.

RELIEF PITCHER

The relief pitcher always has a cleaner uniform than the pitcher he's relieved.

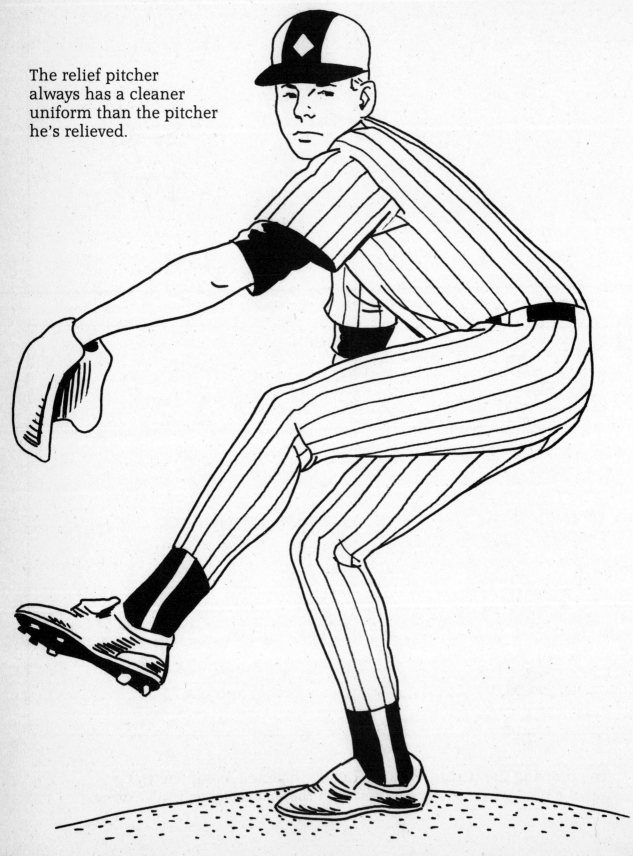

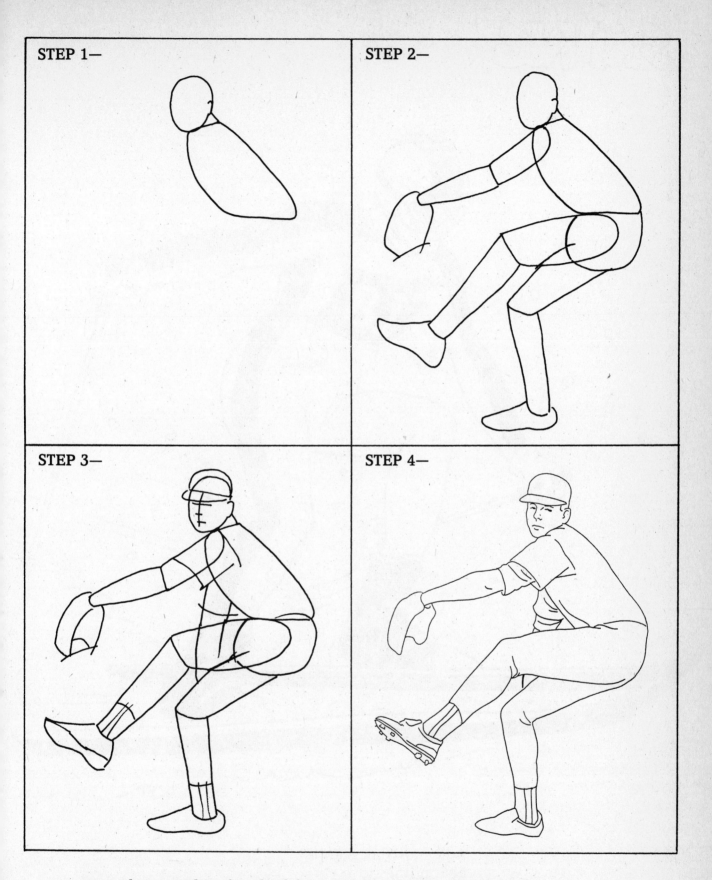

STEP 1—

STEP 2—

STEP 3—

STEP 4—

Draw the complete finished figure before adding black areas and pinstripes. Notice that the pinstripes follow the form and direction of the figure.

SKIING

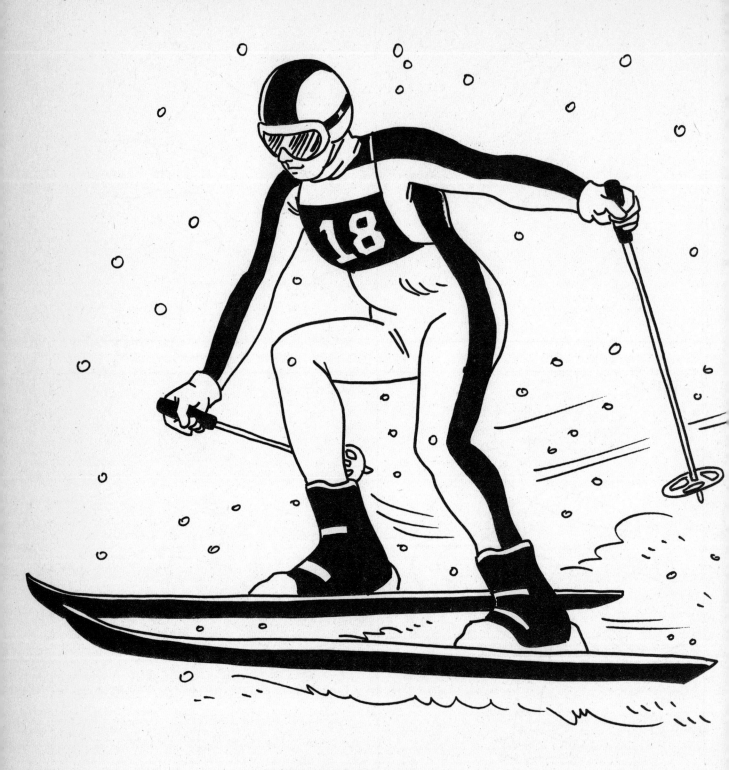

Add snowflakes and
action lines to
put this figure in motion.

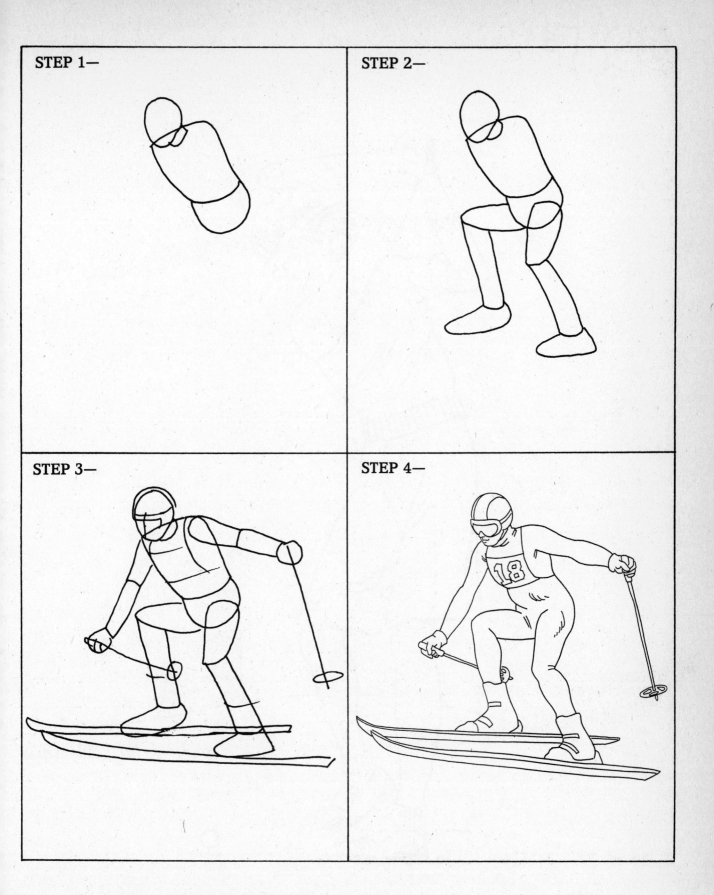

STEP 1—

STEP 2—

STEP 3—

STEP 4—

Draw the shapes for the skis, poles and helmet only after you've completed the shapes of the figure.

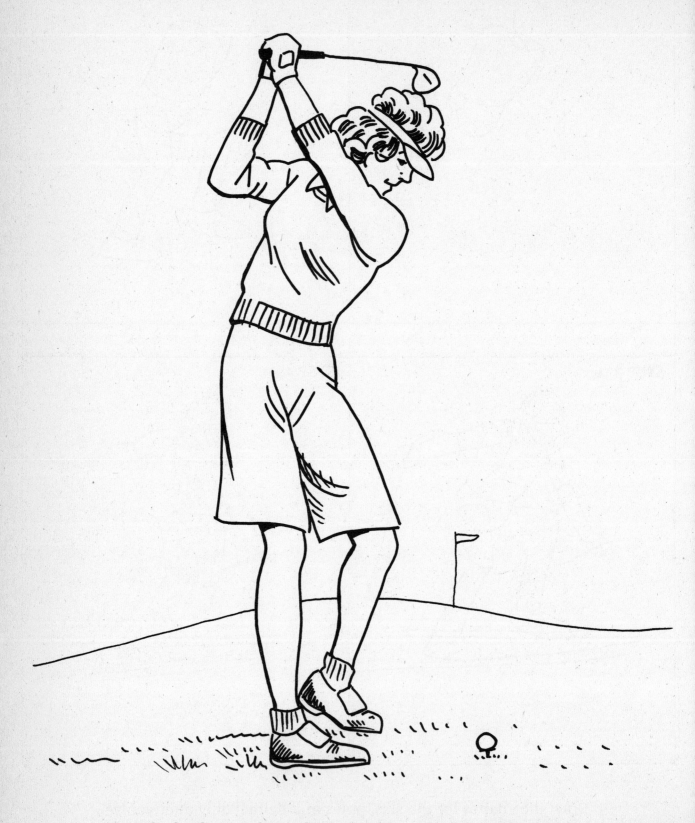

Keep the background simple to put the emphasis on the figure.

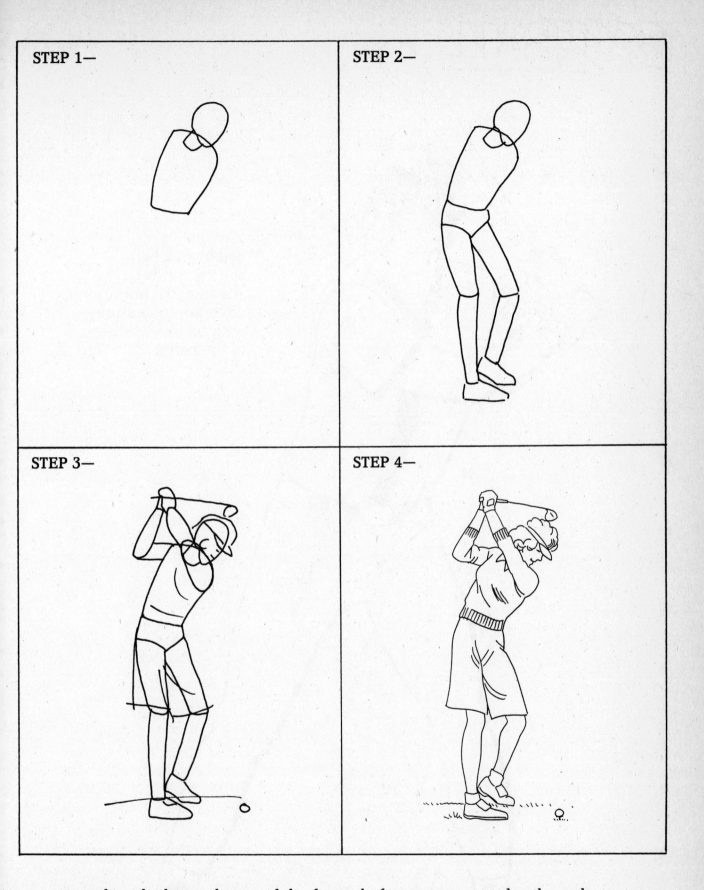

STEP 1—

STEP 2—

STEP 3—

STEP 4—

Complete the basic shapes of the figure before going on to details such as hair, sun visor, club, ball, etc.

BASEBALL

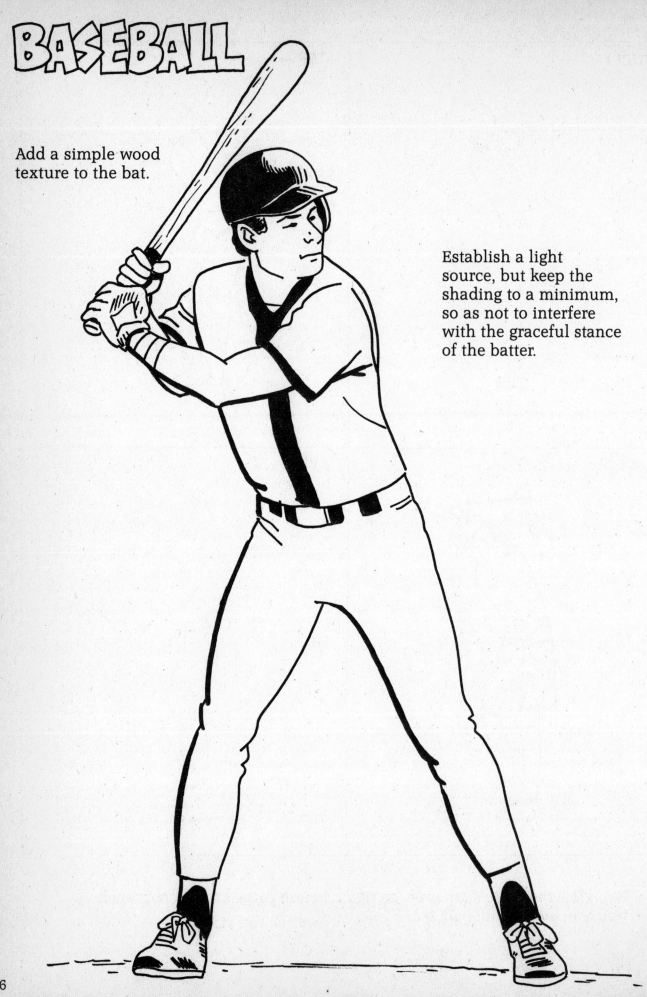

Add a simple wood texture to the bat.

Establish a light source, but keep the shading to a minimum, so as not to interfere with the graceful stance of the batter.

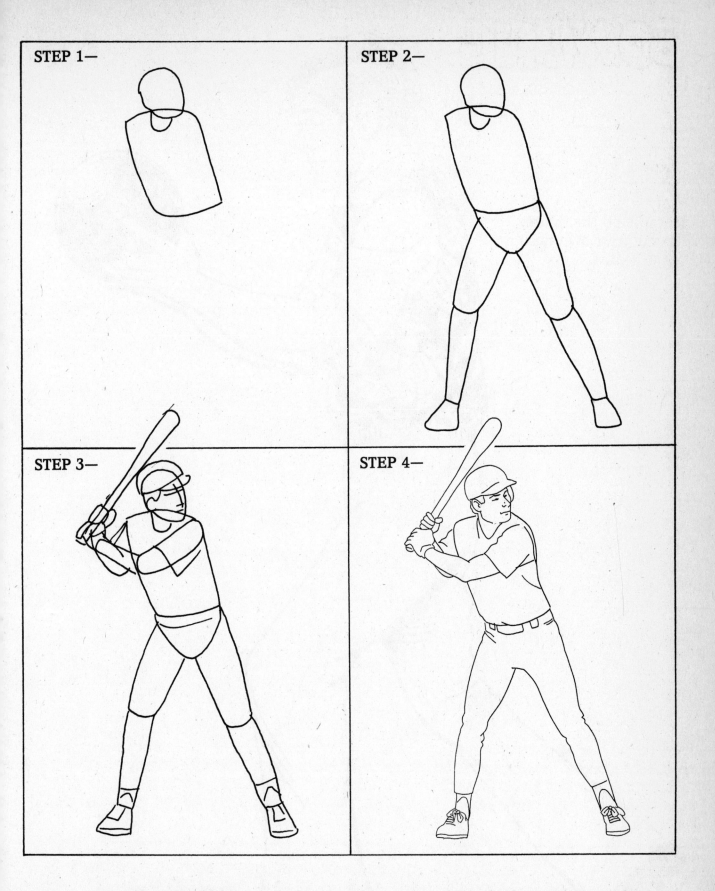

STEP 1—

STEP 2—

STEP 3—

STEP 4—

As with the golf figure on the previous pages, draw the basic shapes of the body first, before adding bat, helmet, shoes, etc.

BOWLING

Draw a "wild" bowling shirt only after you've completed the figure. Create your own design on the shirt.

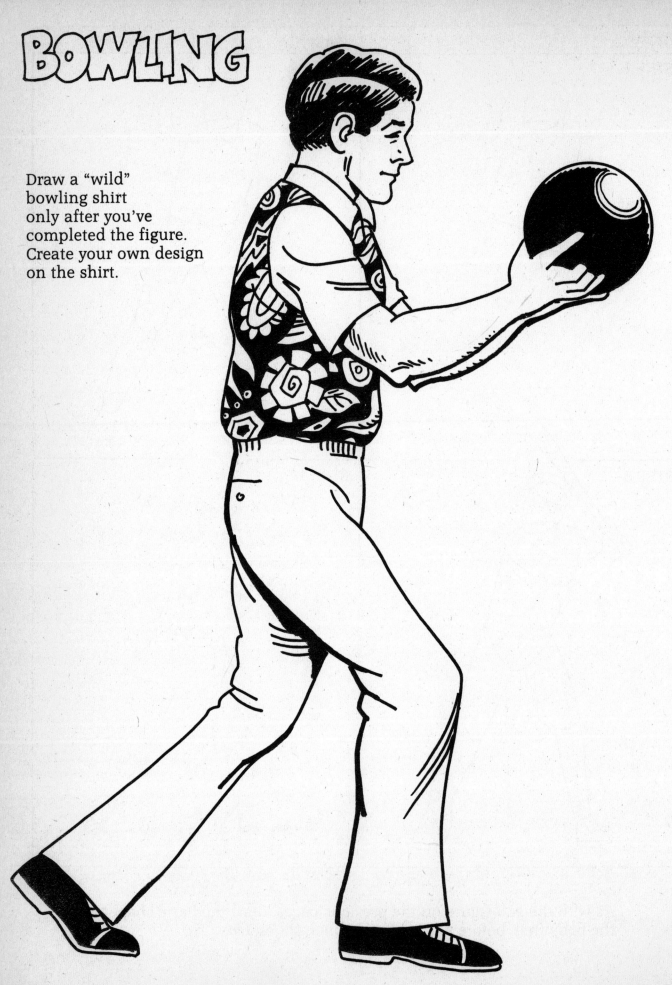

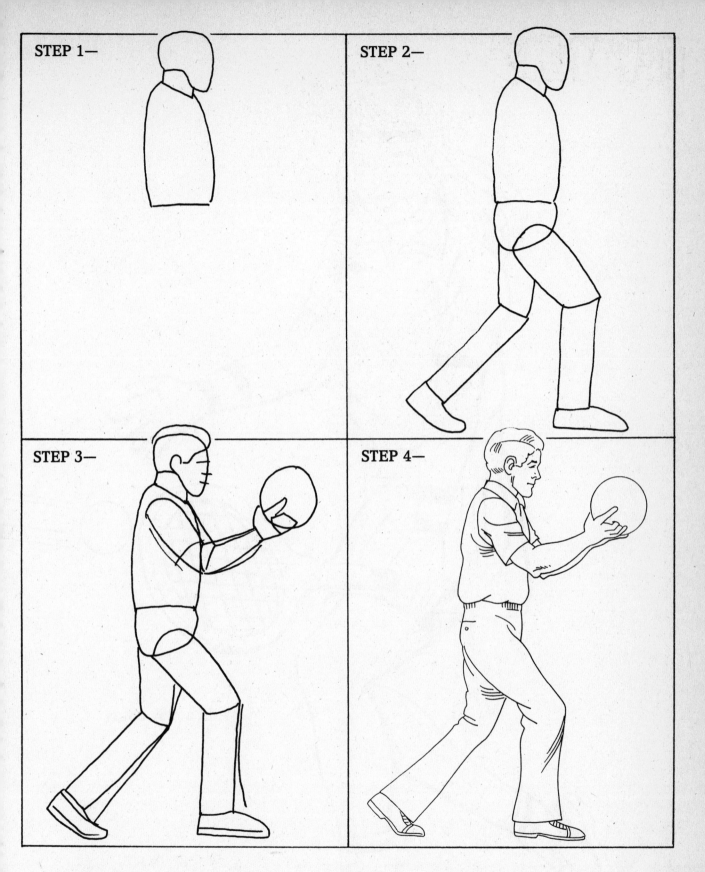

STEP 1—

STEP 2—

STEP 3—

STEP 4—

Keep the shadows simple from the light source. Position the ball correctly in the hands.

TENNIS

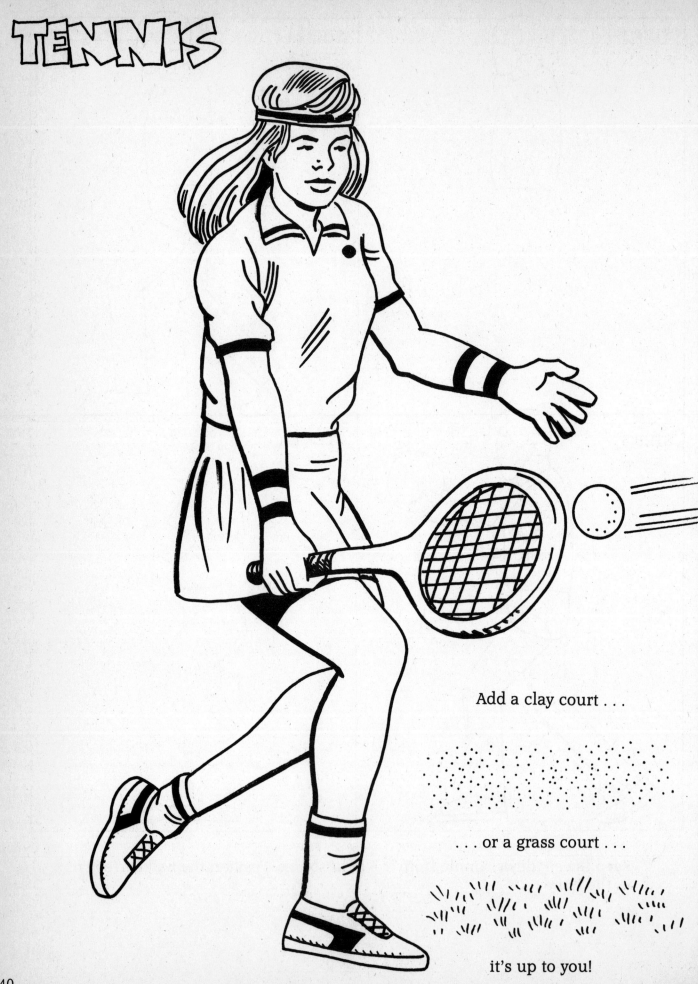

Add a clay court . . .

. . . or a grass court . . .

it's up to you!

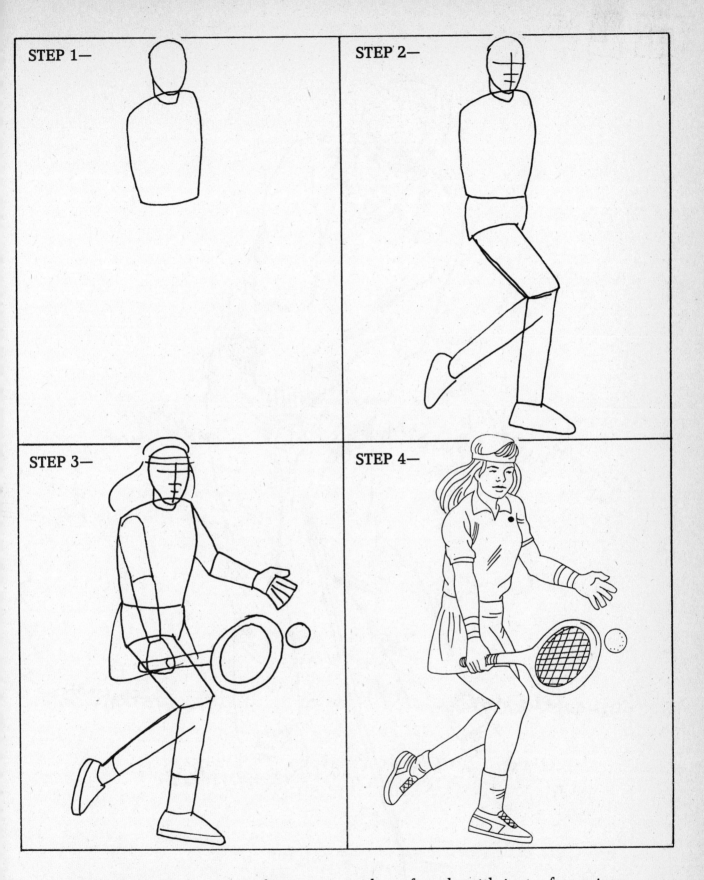

STEP 1—

STEP 2—

STEP 3—

STEP 4—

You can draw the action figure as a male or female with just a few minor changes.

A simple shrub adds
dimension to the scene.

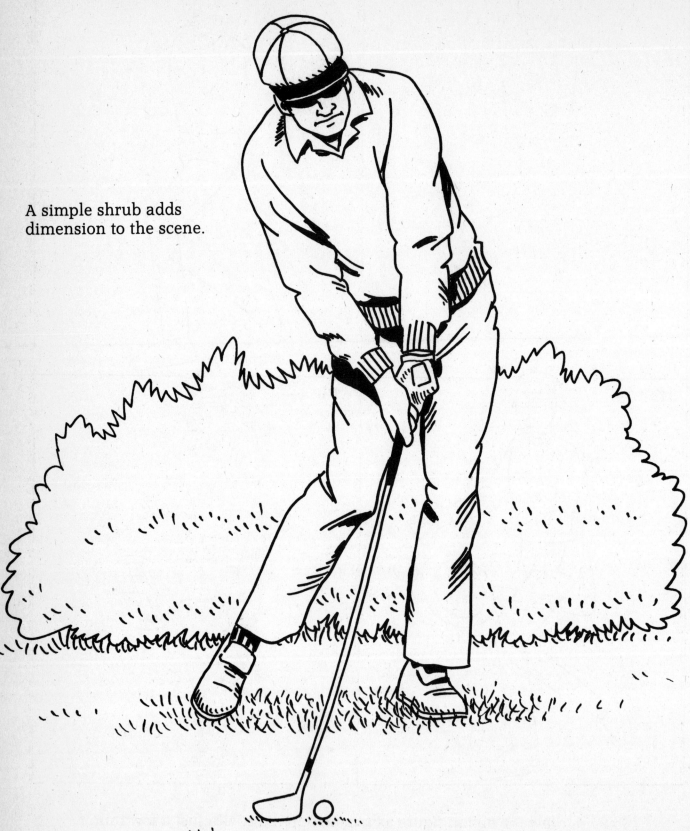

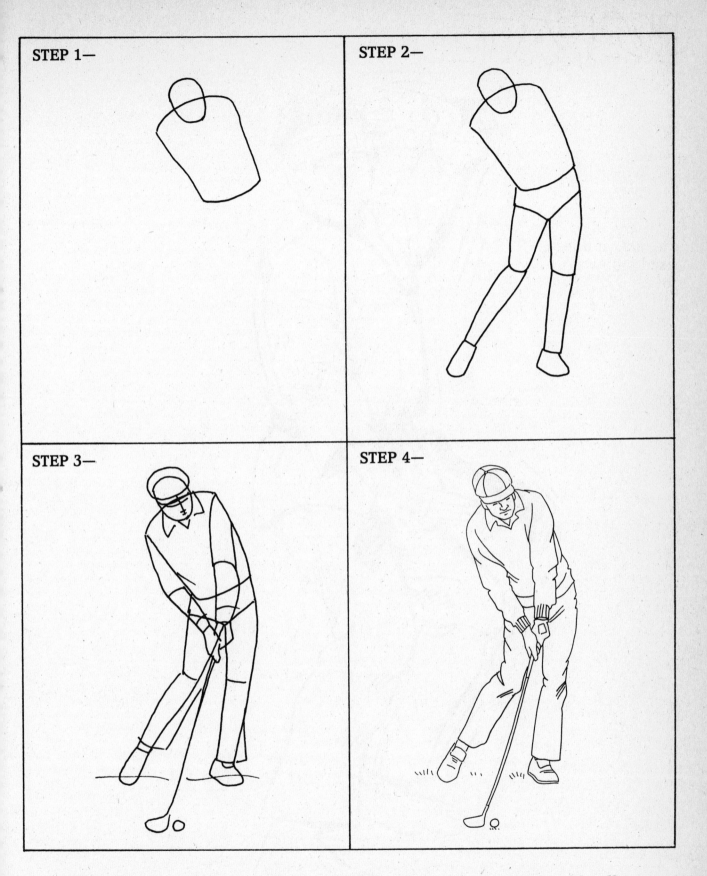

STEP 1—

STEP 2—

STEP 3—

STEP 4—

Even though a shadow from the cap covers the eyes, the eyes should still be drawn in position to establish the form.

KARATE

The action lines
used follow the
form.

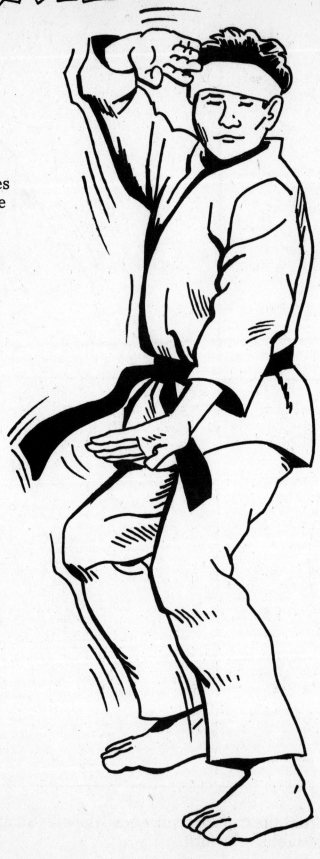

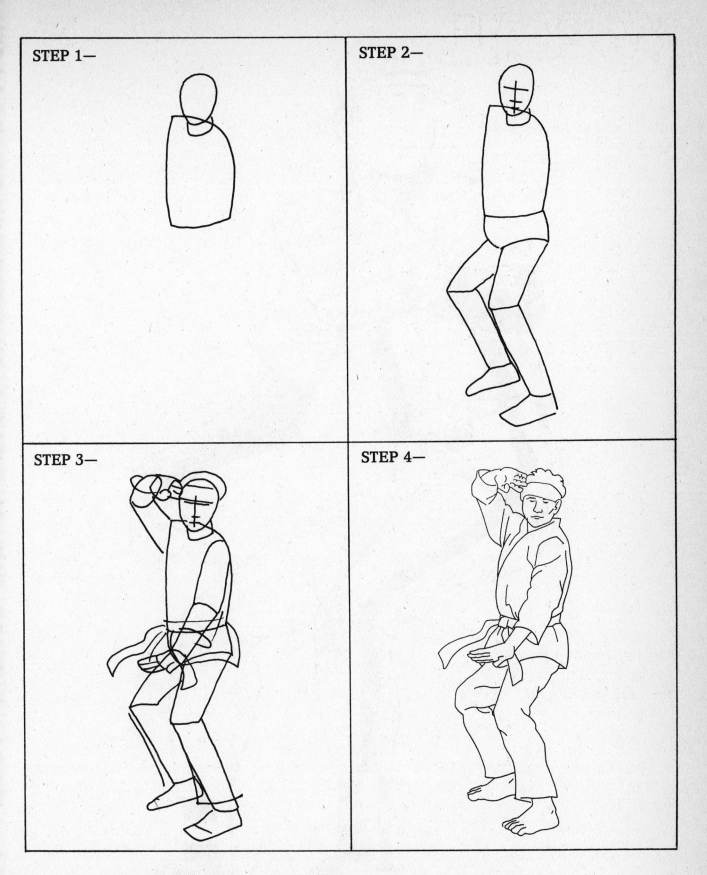

STEP 1—

STEP 2—

STEP 3—

STEP 4—

The baggy clothing fits over the basic shapes of the figure.

BASEBALL

A combination of line and blacks has been used for shadows.

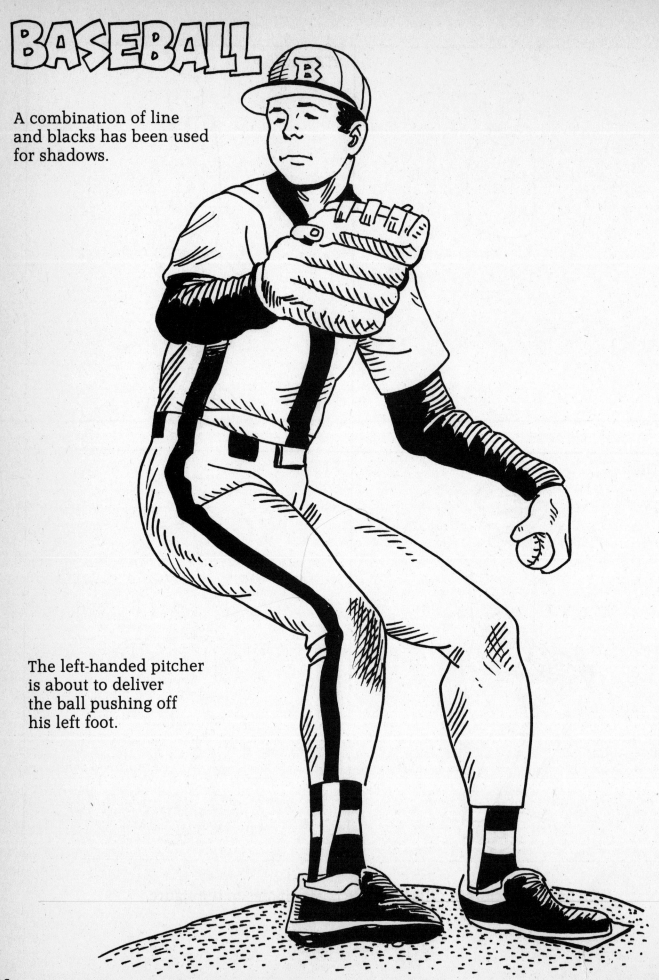

The left-handed pitcher is about to deliver the ball pushing off his left foot.

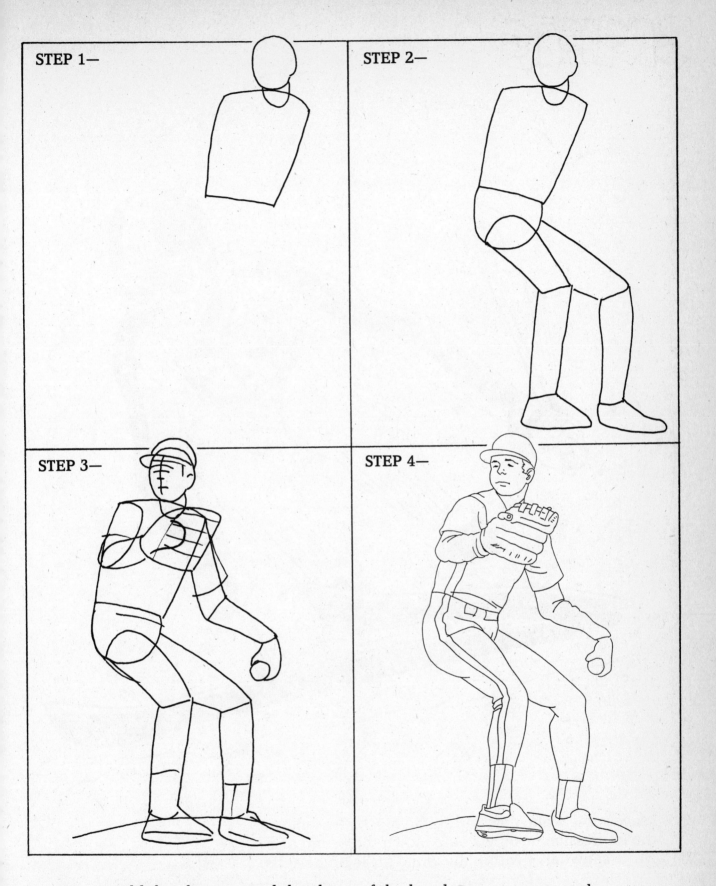

STEP 1—

STEP 2—

STEP 3—

STEP 4—

Build the glove around the shape of the hand. Draw texture on the mound to plant the figure on a surface.

SKIING

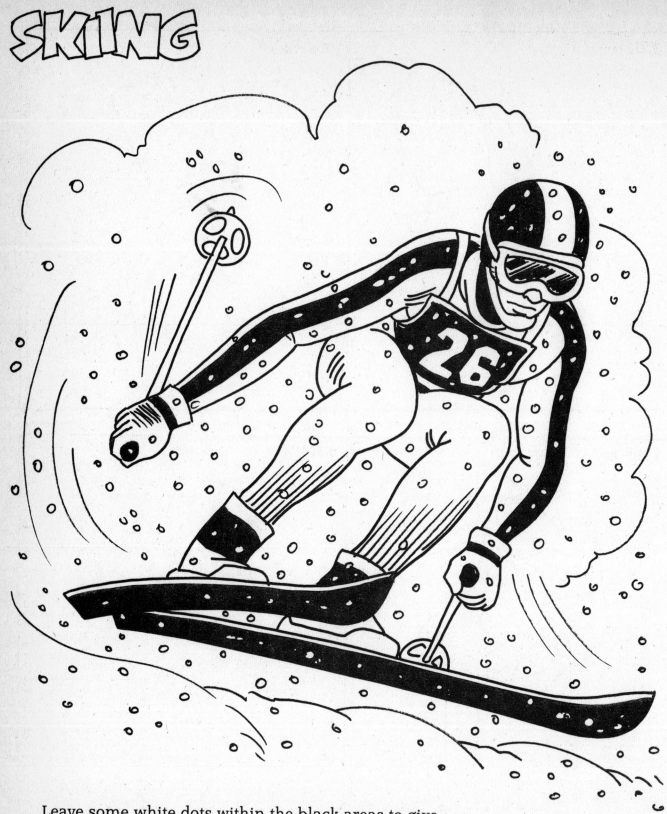

Leave some white dots within the black areas to give the impression of snow being blown there, and also white snowflakes within the white areas of the skier.

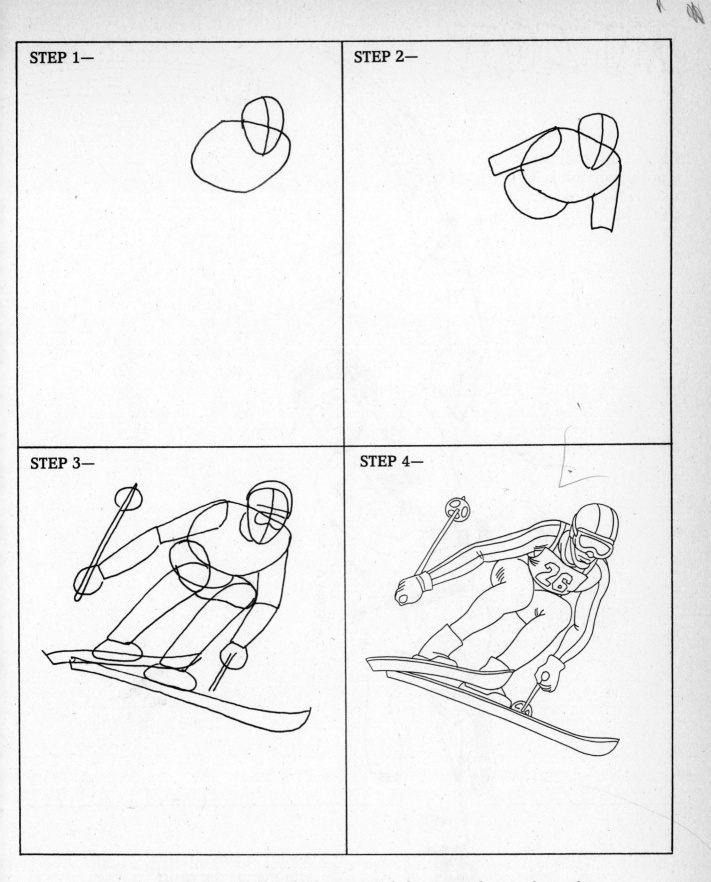

STEP 1—

STEP 2—

STEP 3—

STEP 4—

Draw the background cloud of snow and the ground-snow line after you've completed the line part of your drawing.

JAI ALAI

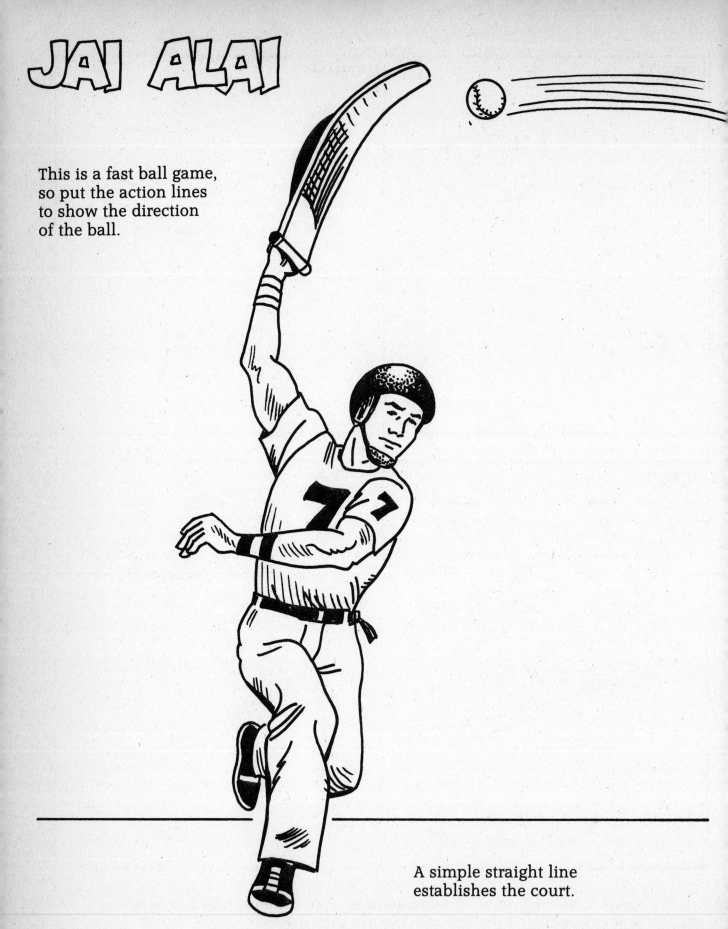

This is a fast ball game, so put the action lines to show the direction of the ball.

A simple straight line establishes the court.

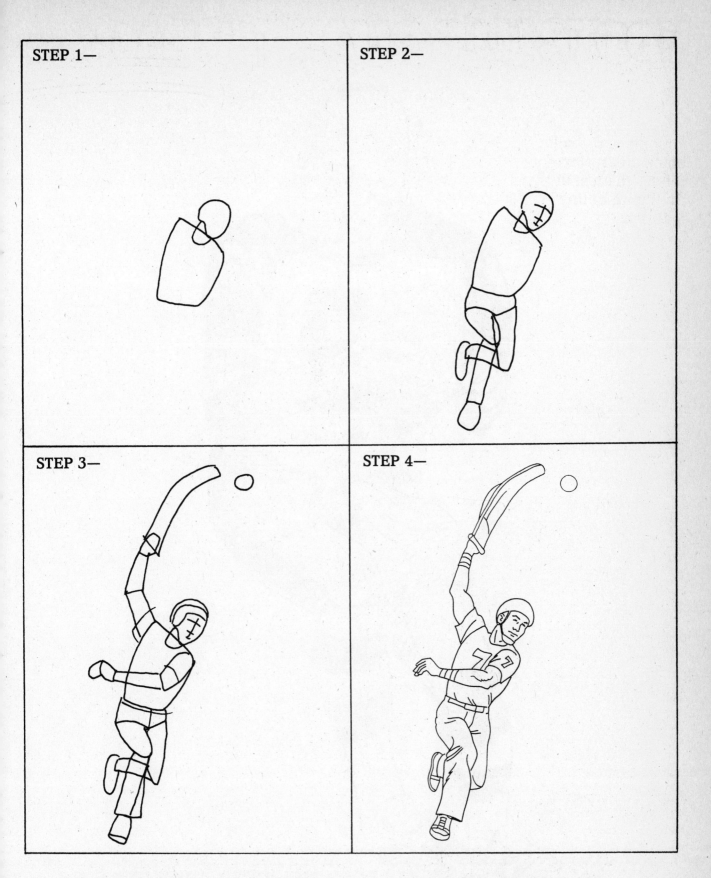

STEP 1—

STEP 2—

STEP 3—

STEP 4—

Draw the wicker basket (the *cesta*), to the hand. *Pelota* is another name for this game.

FOOTBALL QUARTERBACK

First place the solid black areas. Next render the rest of the figure in line textures.

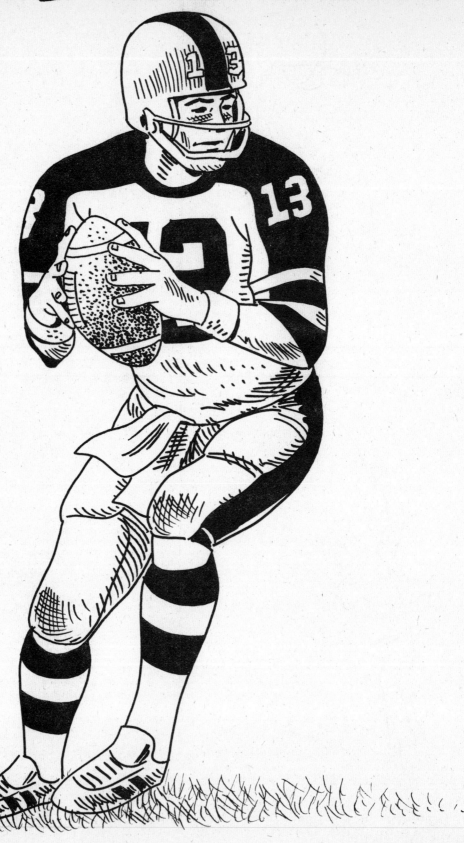

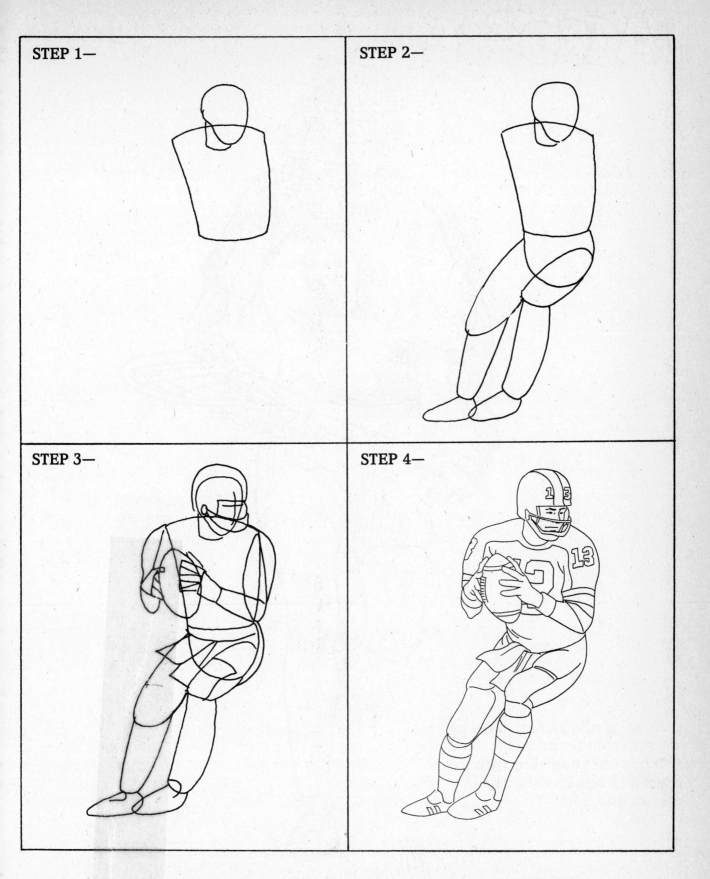

STEP 1—

STEP 2—

STEP 3—

STEP 4—

Draw the basic shapes of the figure, then add padding, helmet, etc.

LACROSSE

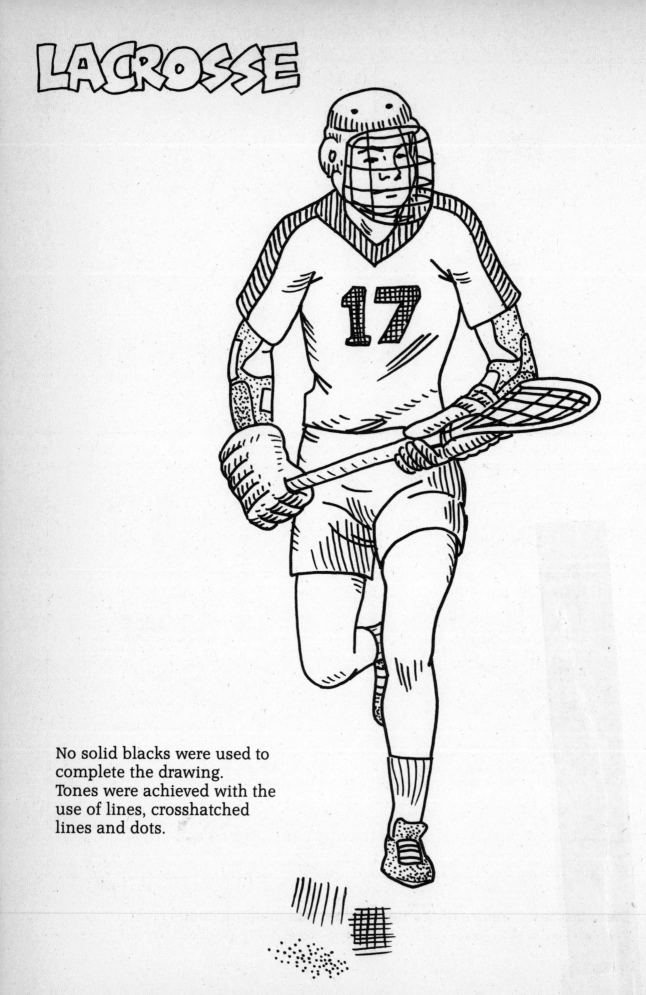

No solid blacks were used to complete the drawing. Tones were achieved with the use of lines, crosshatched lines and dots.

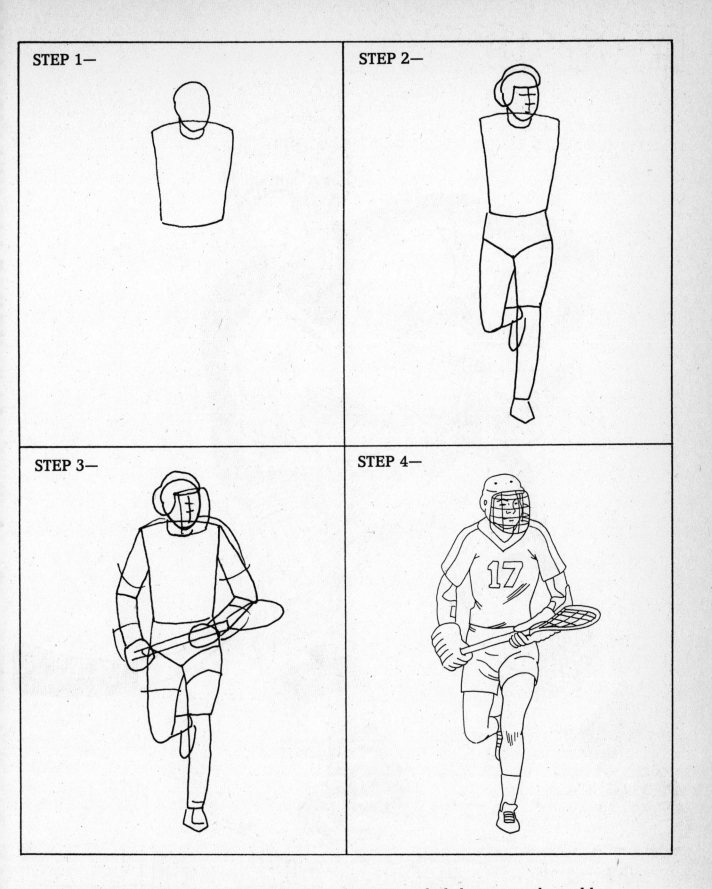

STEP 1—

STEP 2—

STEP 3—

STEP 4—

Just a reminder to draw the first three steps lightly in pencil—and be satisfied with your basic shapes—before completing the drawing.

HOCKEY

This was drawn using textures and blacks.

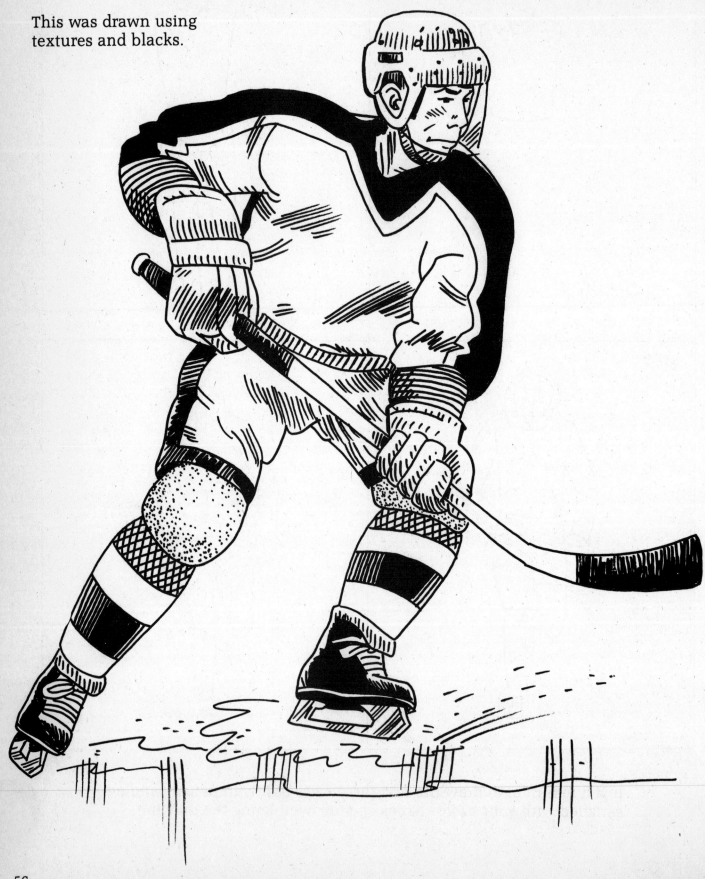

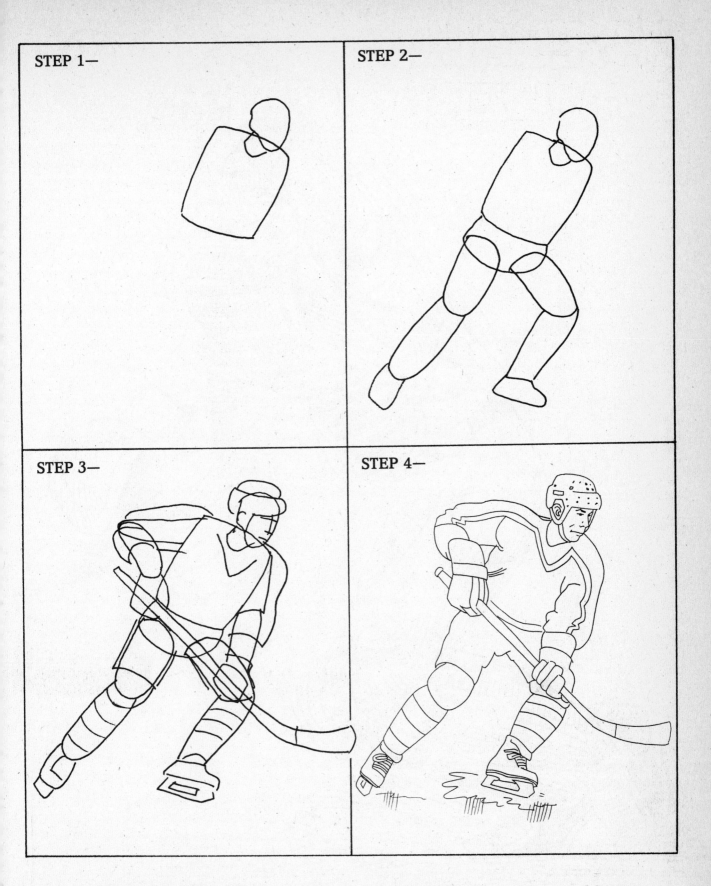

STEP 1—

STEP 2—

STEP 3—

STEP 4—

Completely draw the basic shapes of the figure before adding padding and equipment.

BASEBALL CATCHER

This is an opportunity to have fun using all kinds of textures.

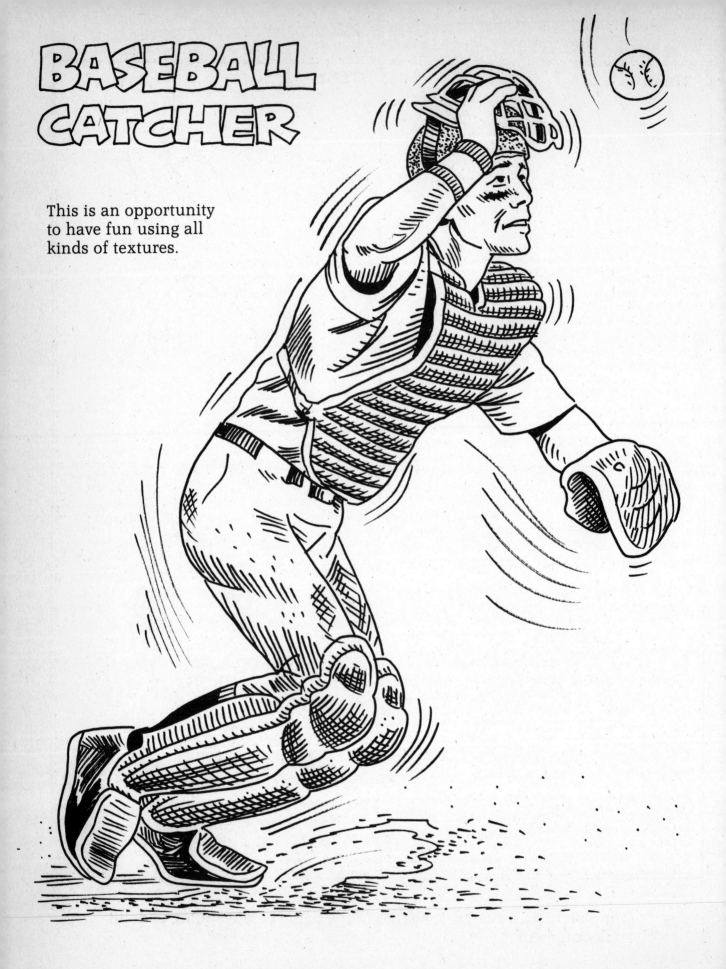

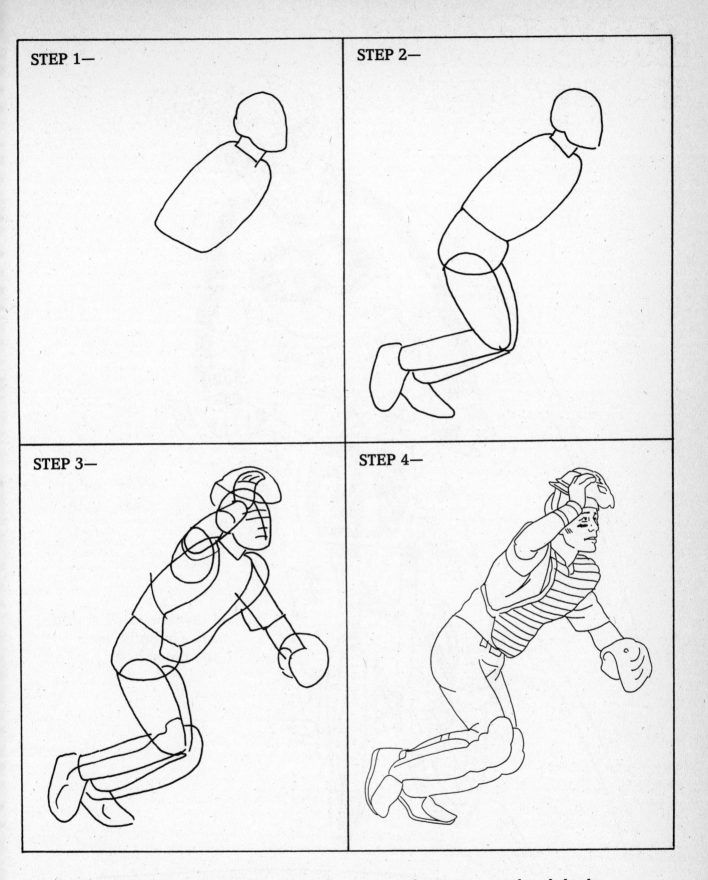

STEP 1—

STEP 2—

STEP 3—

STEP 4—

Do not attempt to draw any textures until you've completed the line drawing.

BMX RACING
BICYCLE MOTOCROSS

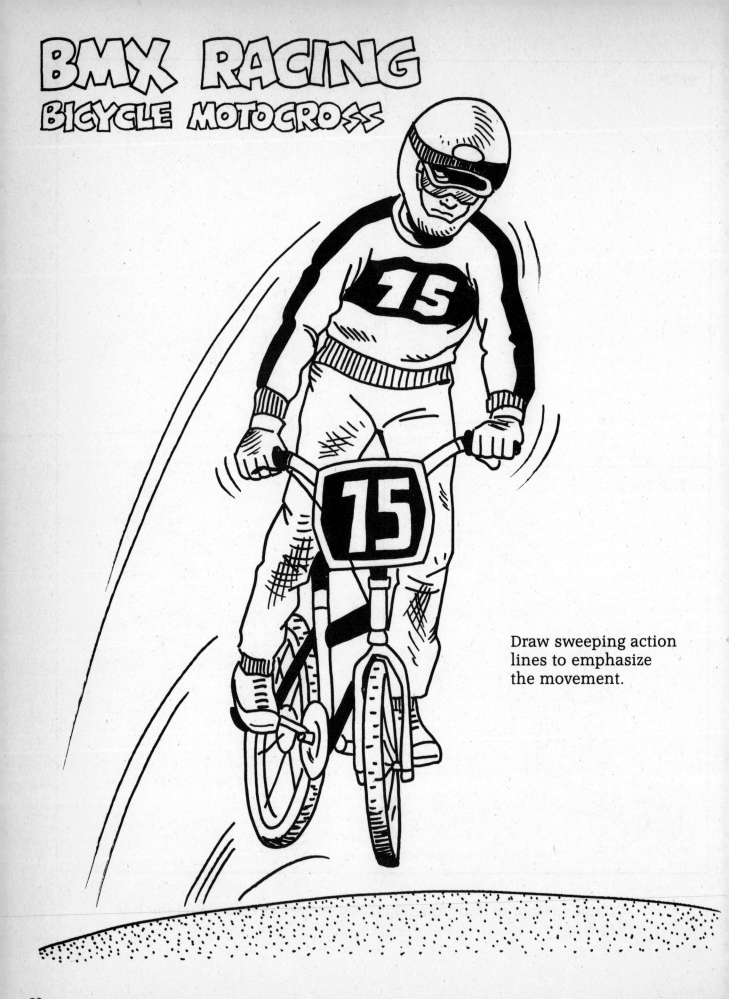

Draw sweeping action lines to emphasize the movement.

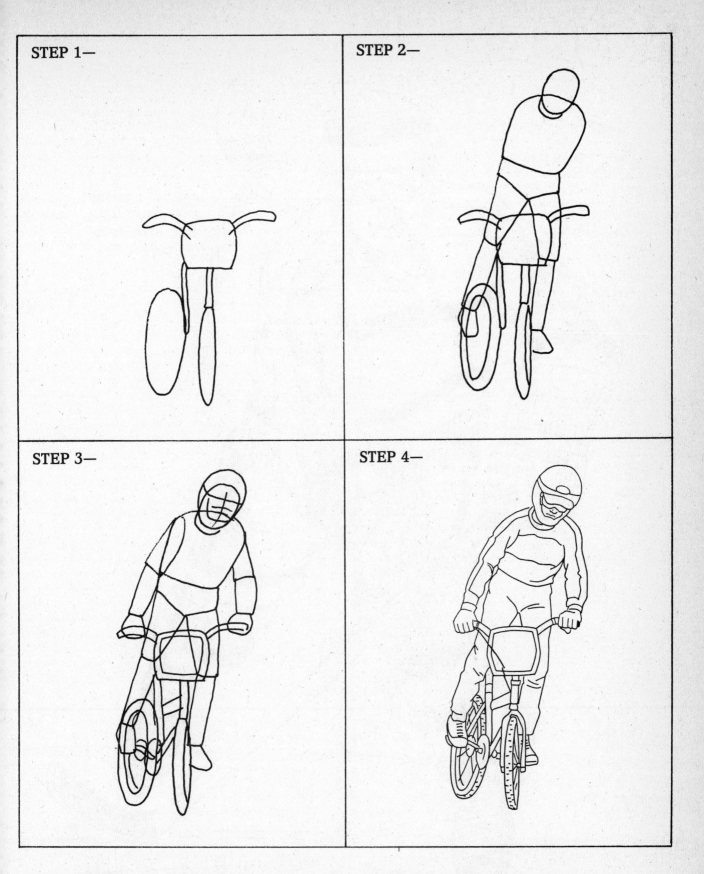

STEP 1—

STEP 2—

STEP 3—

STEP 4—

Position the bike's basic shapes, then build the figure's basic shapes on it. Finish the drawing only after you're satisfied with the basic shapes.

HOCKEY

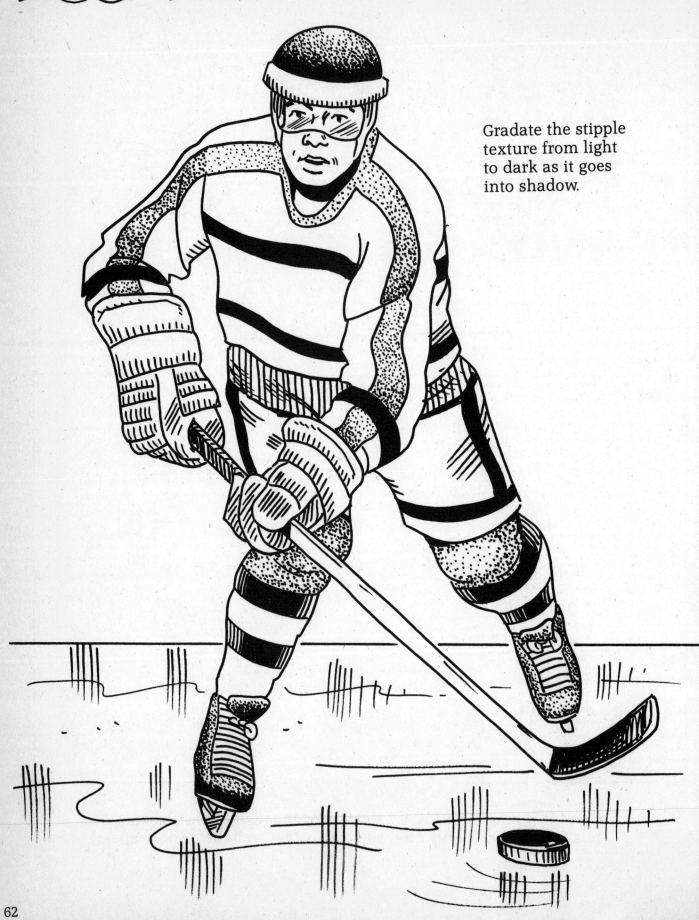

Gradate the stipple
texture from light
to dark as it goes
into shadow.

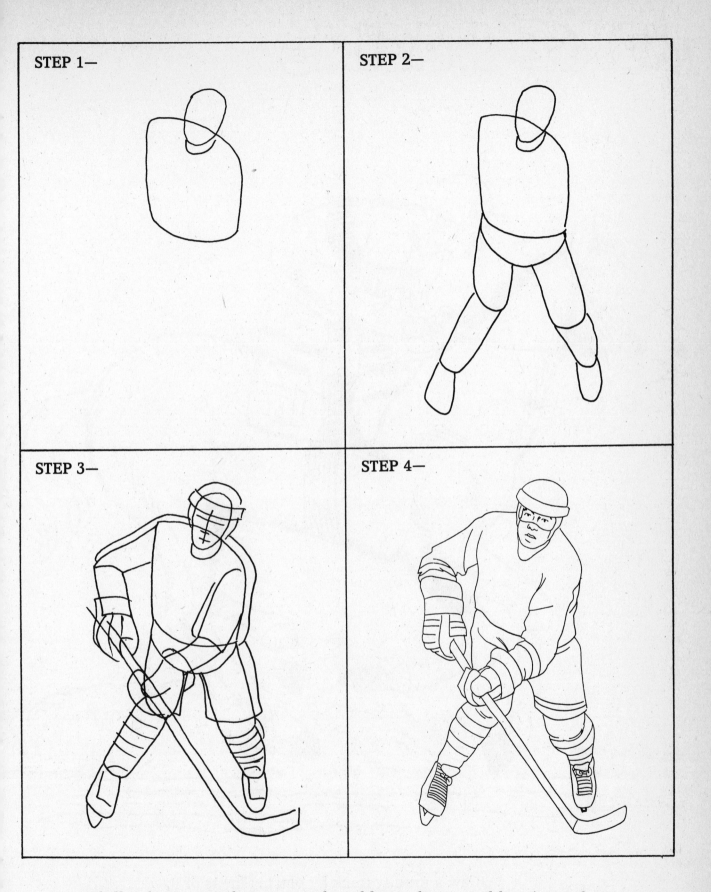

STEP 1—

STEP 2—

STEP 3—

STEP 4—

Solidly place your player on ice by adding a horizontal line (to enclose the ice area), and then parallel vertical lines (for ice shimmer) and a few skate marks on the ice. Don't forget the puck.

HORSE RACING

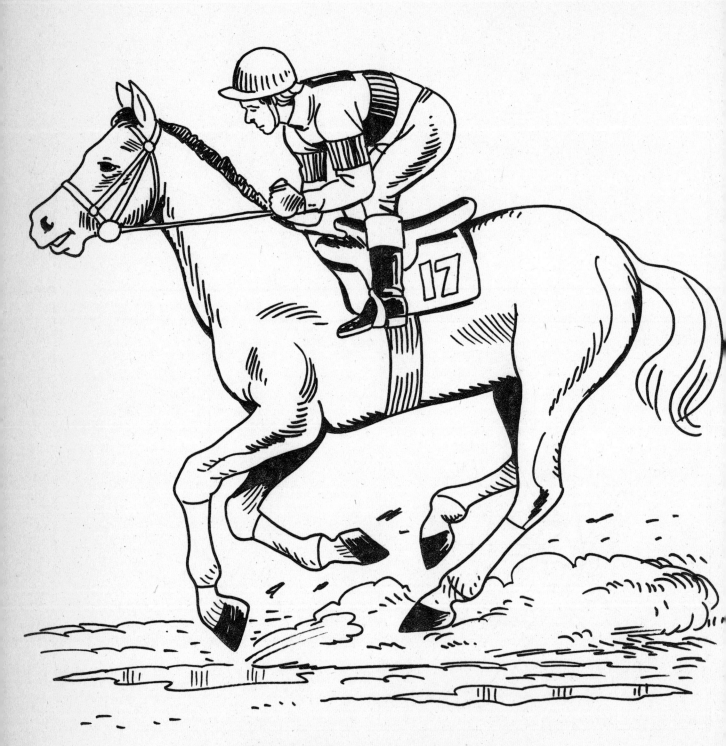

Draw a muddy track by placing areas of water on the turf.

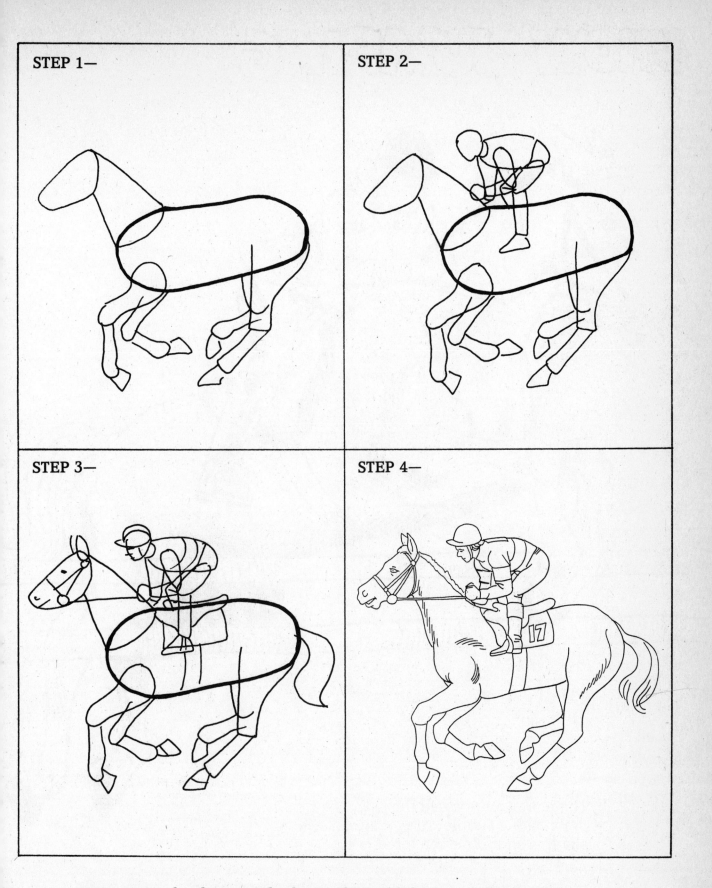

STEP 1—

STEP 2—

STEP 3—

STEP 4—

Begin step 1 by drawing the basic shape of the horse that has been outlined in a broader line. Next add on all the other shapes of the horse. Now begin drawing the shapes of the rider.

SHOW JUMPING

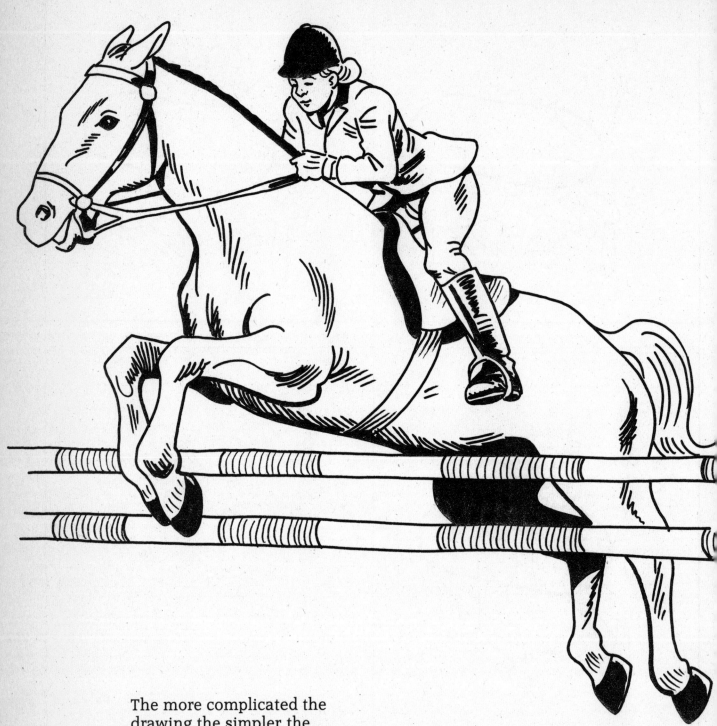

The more complicated the drawing the simpler the shading should be rendered.

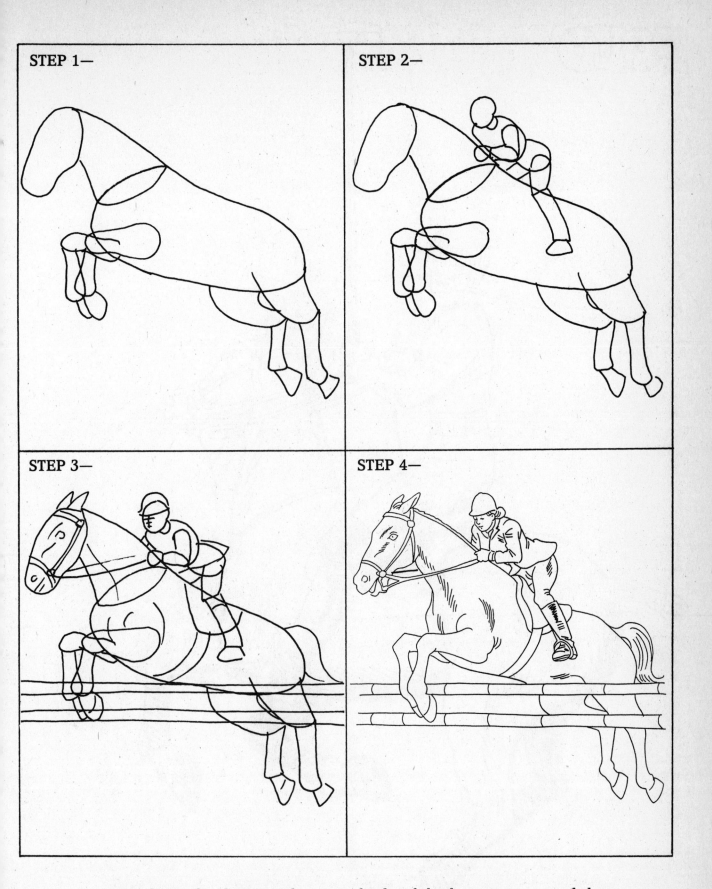

STEP 1—

STEP 2—

STEP 3—

STEP 4—

Again begin by drawing the main body of the horse's torso and then adding the other basic shapes to it, including the shapes of the rider.

POLO

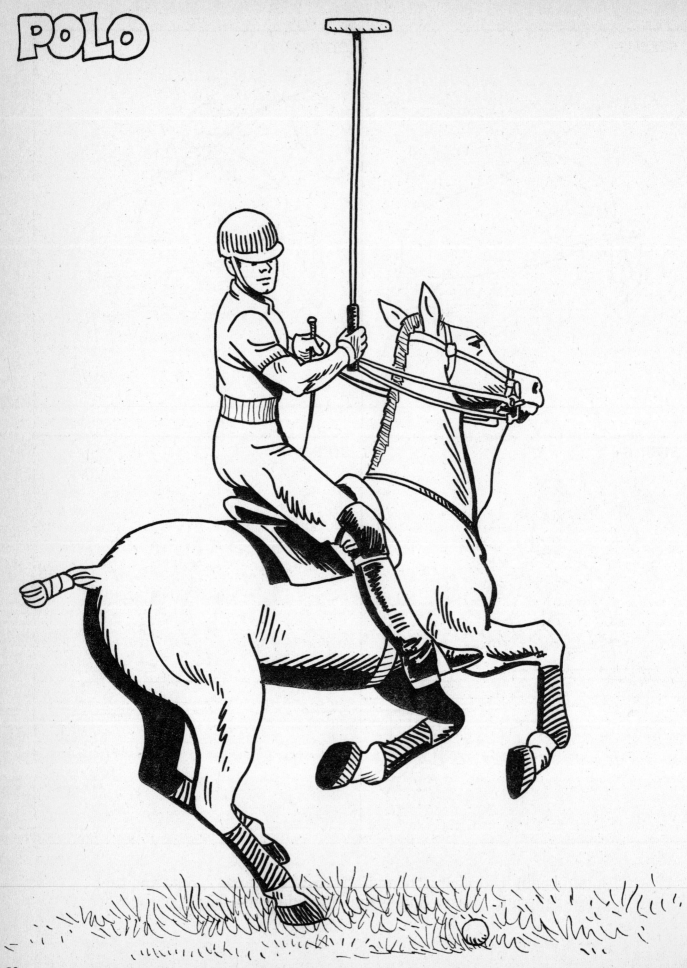

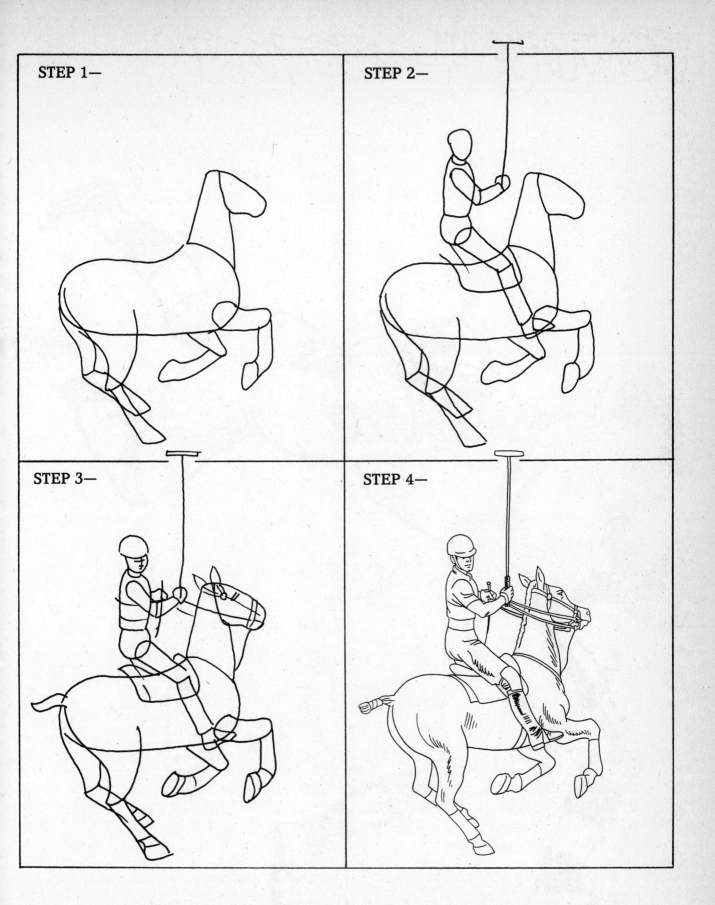

STEP 1—

STEP 2—

STEP 3—

STEP 4—

Any drawing of a horse and rider is difficult. By carefully following the steps shown above it will make drawing this picture less difficult.

FOOTBALL ACTION

Keep the shading simple so as not to slow down the action.

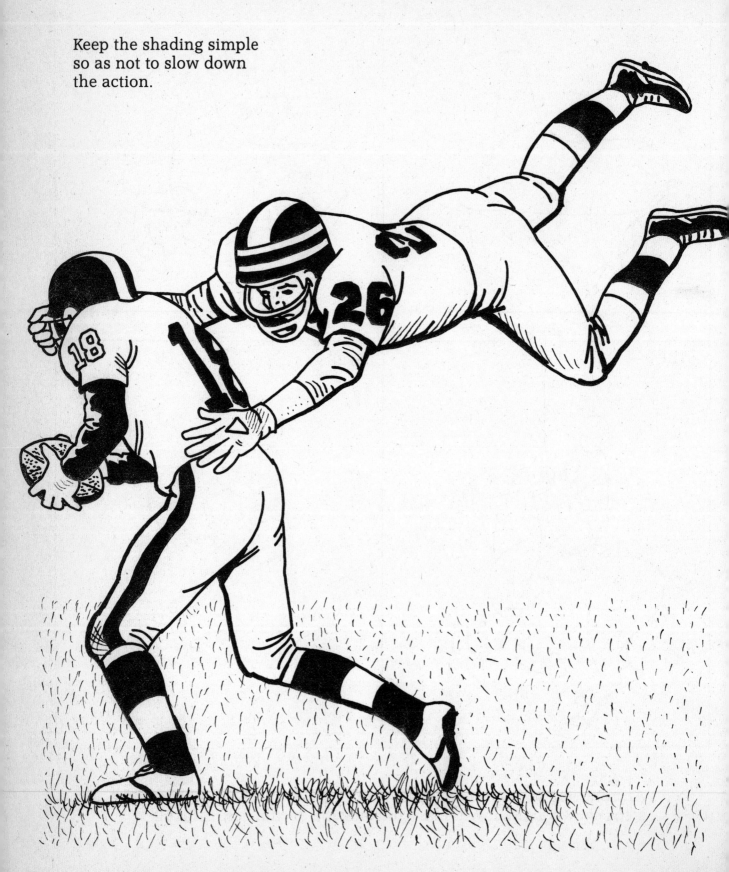

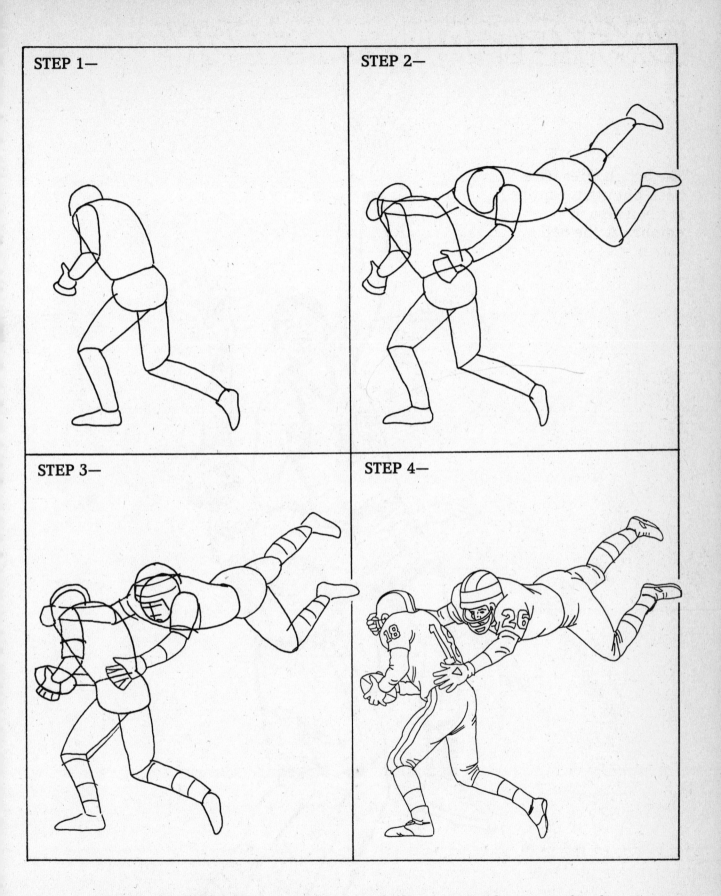

STEP 1—

STEP 2—

STEP 3—

STEP 4—

Follow the first three basic steps carefully to set up the action for the finished drawing.

BASKETBALL ACTION

The action lines have been put in only near the ball area to emphasize the ball's action.

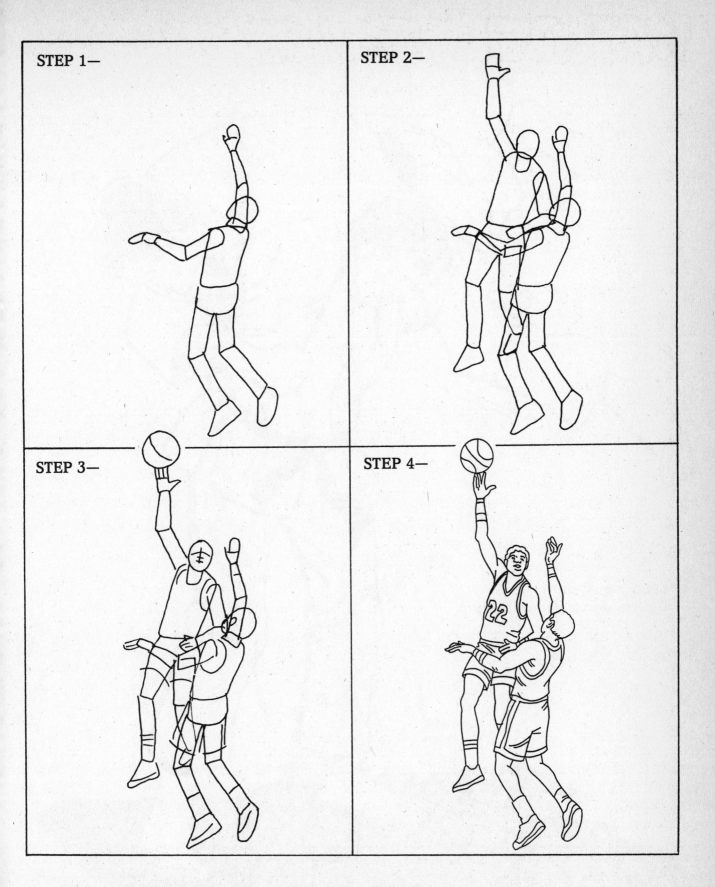

STEP 1—

STEP 2—

STEP 3—

STEP 4—

Draw all the basic shapes of both figures, whether or not they are seen in the final drawing, to establish relationships of forms.

KARATE ACTION

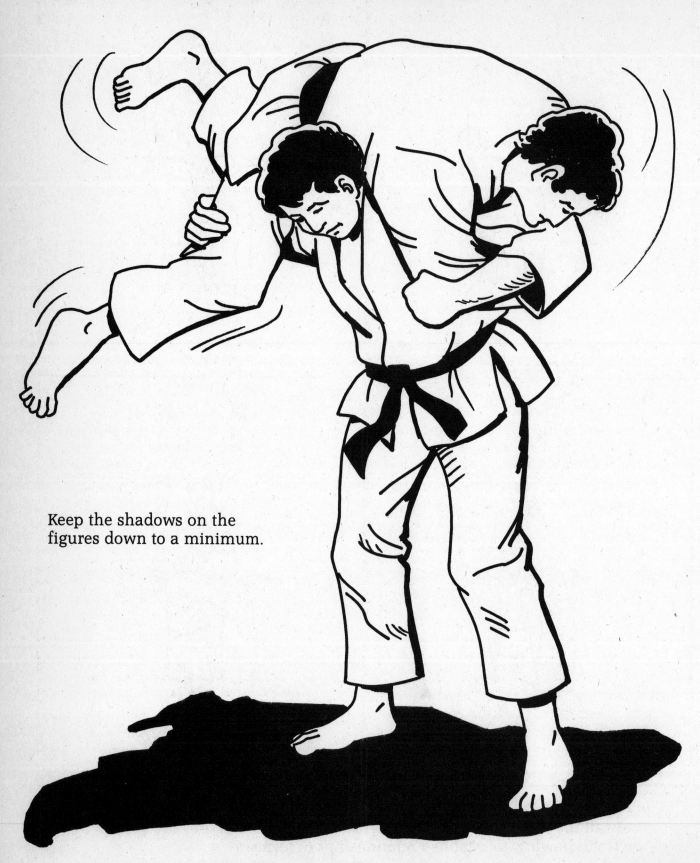

Keep the shadows on the figures down to a minimum.

Establish a ground shadow.

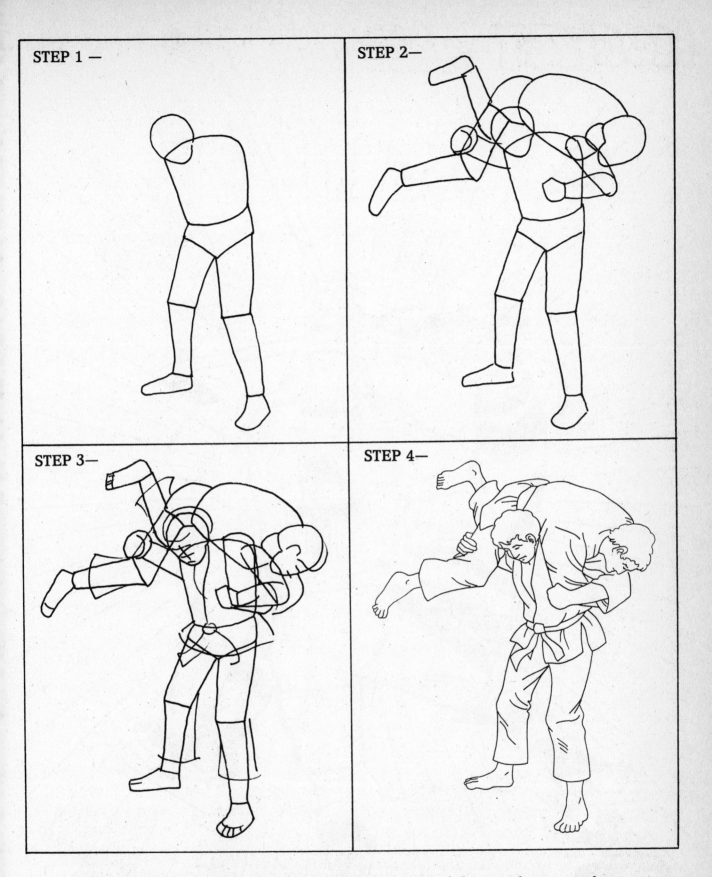

STEP 1 —

STEP 2—

STEP 3—

STEP 4—

This is a complicated drawing of the interaction of the two figures. Take your time drawing the basic shapes and the finished drawing will come together.

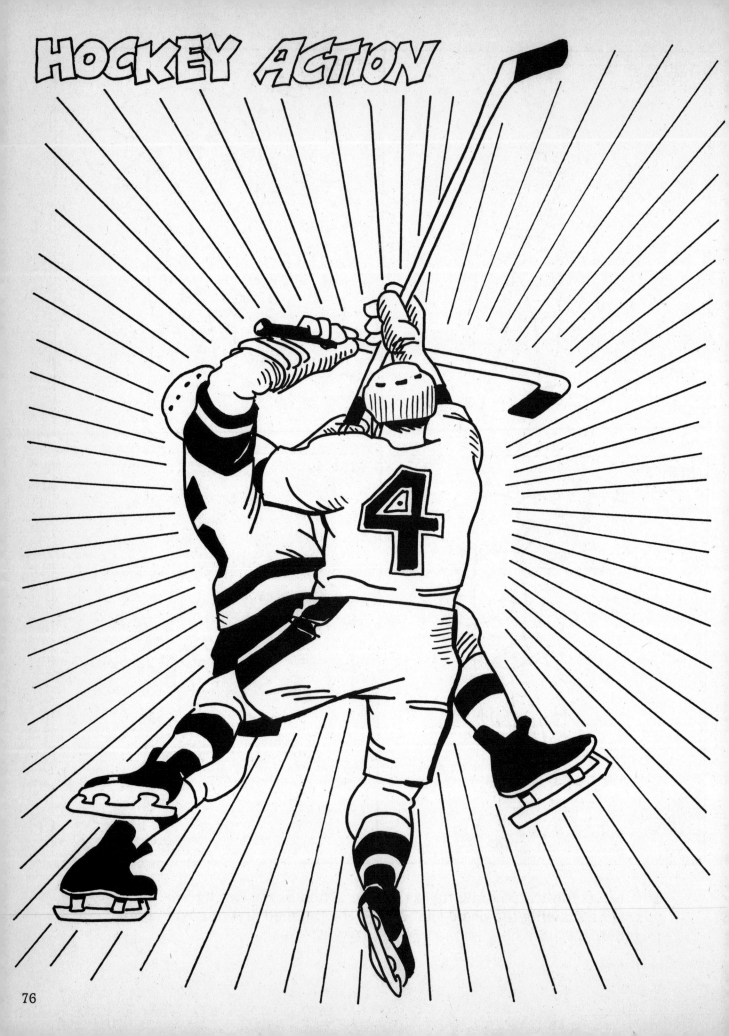

HOCKEY ACTION

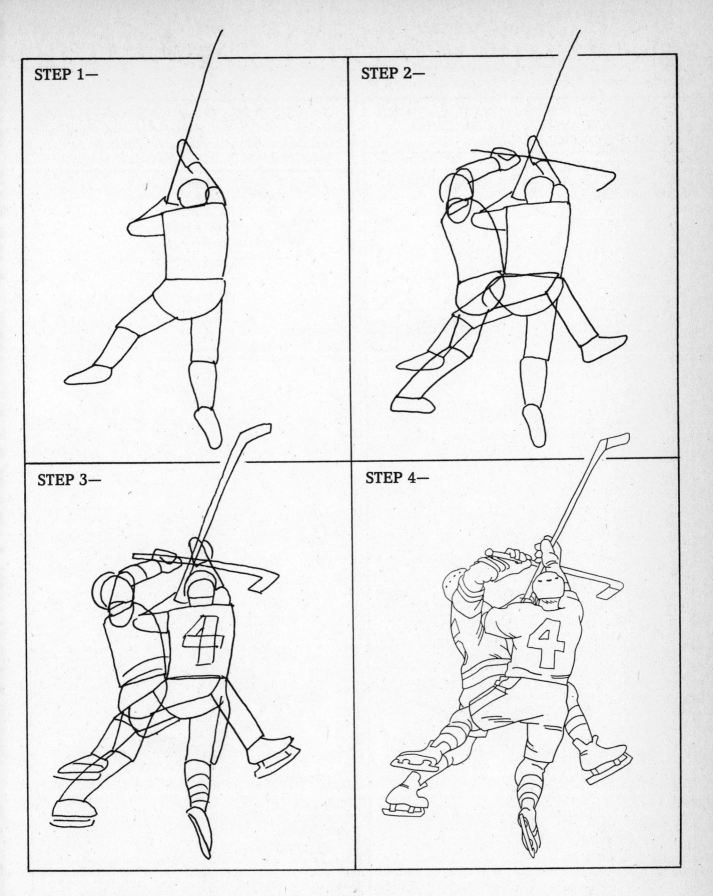

STEP 1—

STEP 2—

STEP 3—

STEP 4—

By drawing straight lines to a point (in this case the dot in the numeral 4), this highlights the clash of these two players.

GOOD NIGHT SPORTS FAN!

YOU CAN MAKE COPIES OF THESE PAGES SO AS NOT TO DRAW IN THIS BOOK.

IT WAS A LATE SUMMER EVENING WHEN YOUR PARENTS CAME TO YOUR BEDROOM DOOR...

PLEASE TAKE OFF ALL THAT GEAR AND GO TO BED!

GOODNIGHT!

AFTER PUTTING AWAY YOUR SPORTS GEAR, YOU QUICKLY FALL OFF TO SLEEP... AND DREAM ABOUT PLAYING PRO FOOTBALL!

GET OUT THERE SPORTS FAN, SO THAT I CAN THROW YOU THE WINNING T.D. !

DRAW ALL☆ CARTOON ON PAGE 82.

DRAW FOOTBALL QUARTERBACK ON PAGE 52.

SUDDENLY YOU FIND YOURSELF
CADDYING IN A GOLF TOURNAMENT!

THANKS FOR
THE CLUB
SPORTS FAN.

DRAW *GOLF* ON PAGE 34.

YOUR DREAM CUTS TO AN ALL-STAR
BASEBALL GAME.... AND YOU ARE
THE BATTER!

JUST TRY
AND HIT MY
FAST BALL!

DRAW *RELIEF PITCHER* ON PAGE 30.

WOW! YOUR DREAM JUST GOT COLD!

LET'S HIT
THE
SLOPES!

DRAW *SKIING* ON PAGE 32.

GULP! YOU ARE FACE TO FACE
WITH YOUR NEXT OPPONENT.

DRAW *BOXING* ON PAGE 22.

YOU ARE NOW AN OFFICIAL AT A PRO HOCKEY GAME!

HEY, REF, CALL A PENALTY!

DRAW *HOCKEY ACTION* ON PAGE 76.

THINGS CALM DOWN AND YOU'RE WITNESSING A MAGICAL OLYMPIC MOMENT.

DRAW *GYMNASTICS* ON PAGE 16.

GEE-WHIZ! WHAT KIND OF A SPORT ARE YOU WATCHING NOW?

DRAW *SWING* ON PAGE 84.

NOW YOU FIND YOURSELF ON A DIRT TRACK.

WANT TO RACE ME, SPORTS FAN?

DRAW *BMX RACING* ON PAGE 60.

THINK QUICK! YOU ARE GUARDING A PRO BASKETBALL PLAYER.

DRAW *BASKETBALL* ON PAGE 6.

YOU'RE AWAKE!!

WOW! WHAT A DREAM!

THE END

DRAW YOURSELF SITTIN' UP IN BED SURROUNDED BY SPORTS GEAR.

81

ALL ☆ CARTOON

Drawing cartoon sports is the same as drawing their more realistic cousins. Start the same way by drawing and adding basic shapes. Add details only after you're happy with the basic shapes.

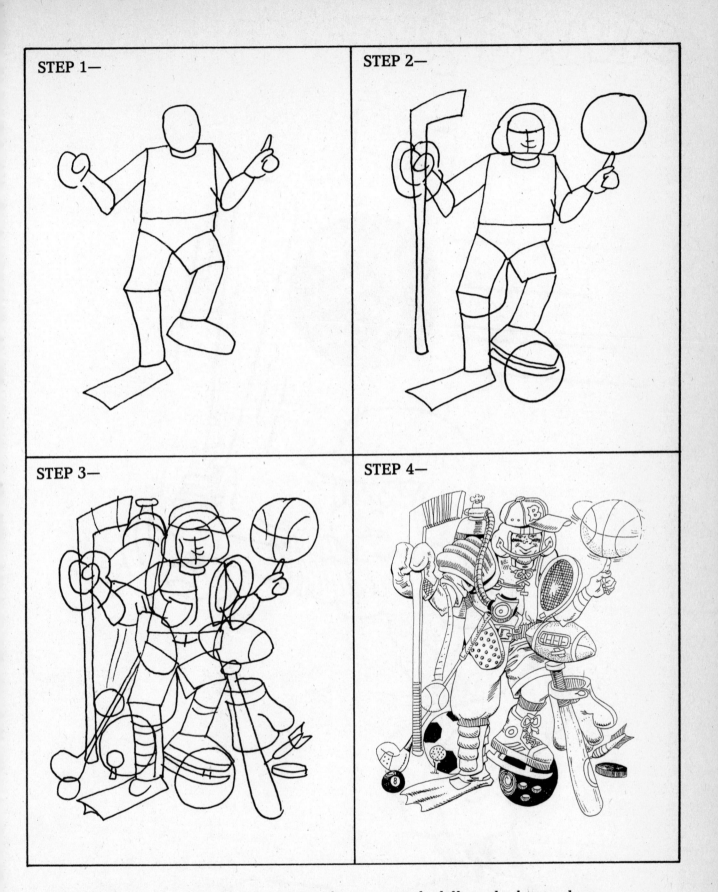

STEP 1—

STEP 2—

STEP 3—

STEP 4—

This is a very involved cartoon figure. Simply follow the basic shapes carefully before adding details.

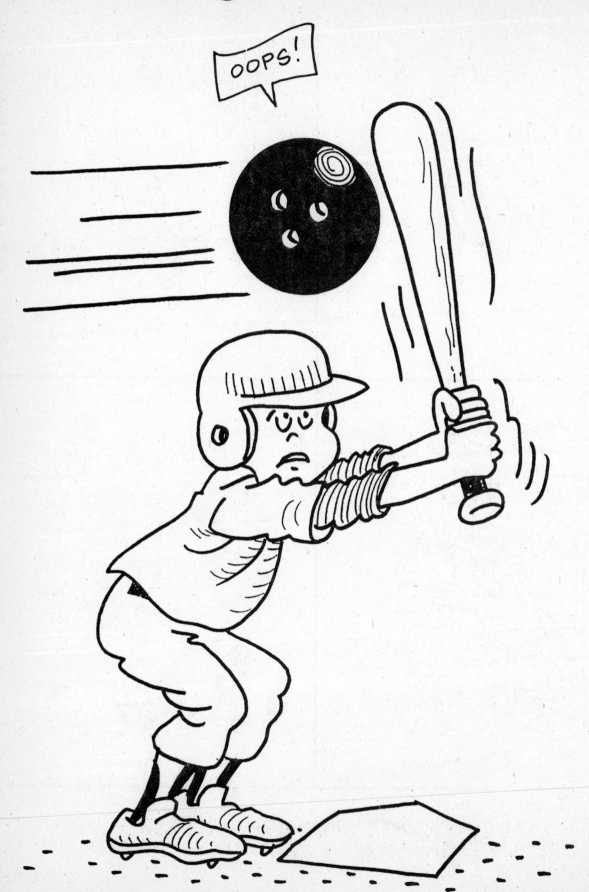

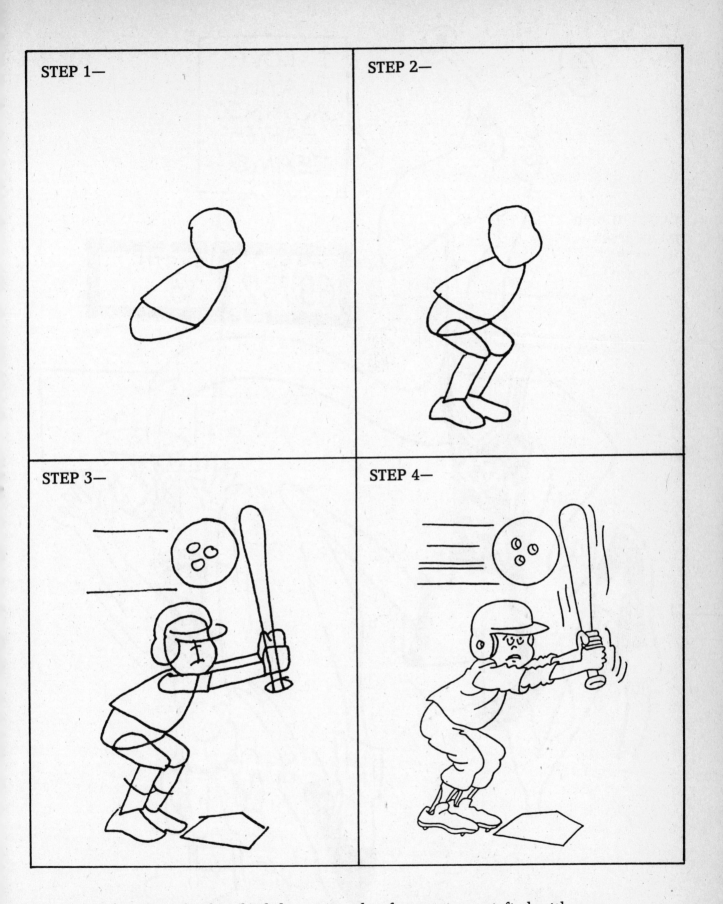

STEP 1—

STEP 2—

STEP 3—

STEP 4—

Swing into the finished drawing only after you're satisfied with your basic shapes, whether you're drawing a realistic or cartoon figure.

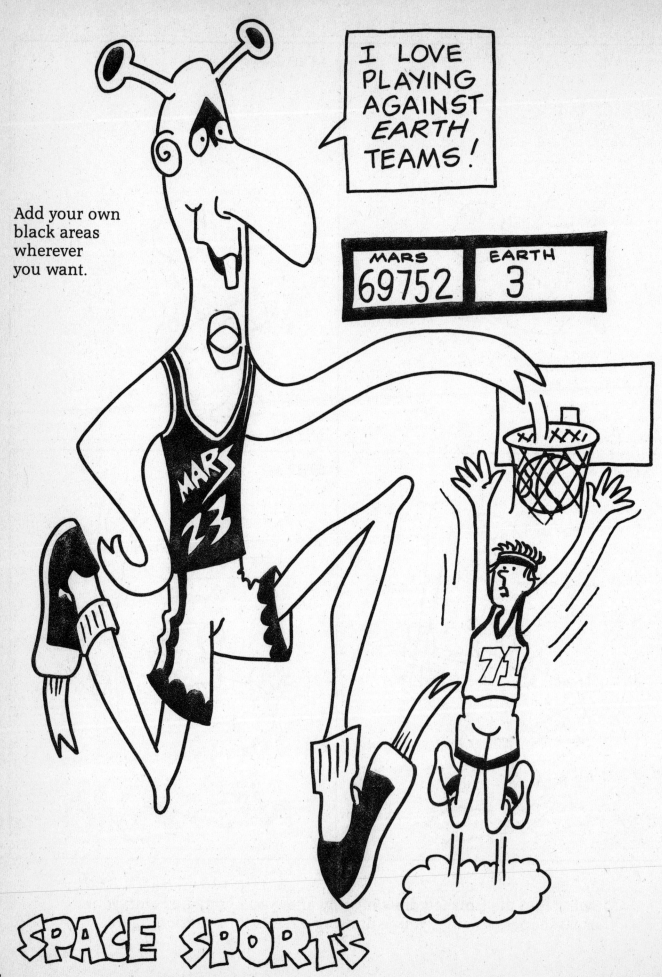

Add your own black areas wherever you want.

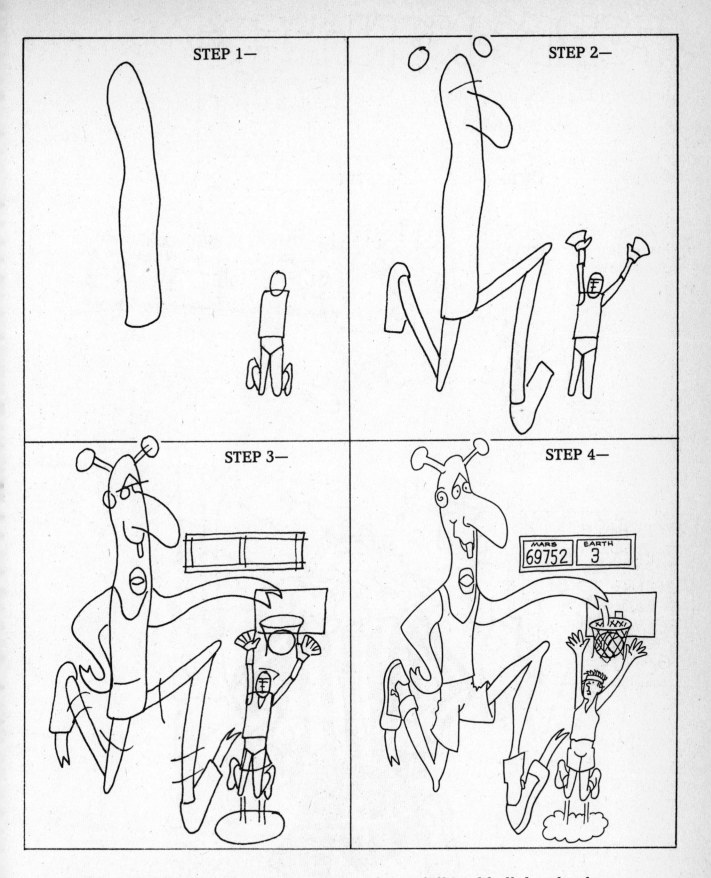

STEP 1—

STEP 2—

STEP 3—

STEP 4—

MARS 69752 EARTH 3

Follow the weird shapes of the space jock carefully. Add all details after all the shapes are properly drawn.

SPORTS-NON-HERO

Refs are still part of the game.

STEP 1— **STEP 2—** **STEP 3—** **STEP 4—**

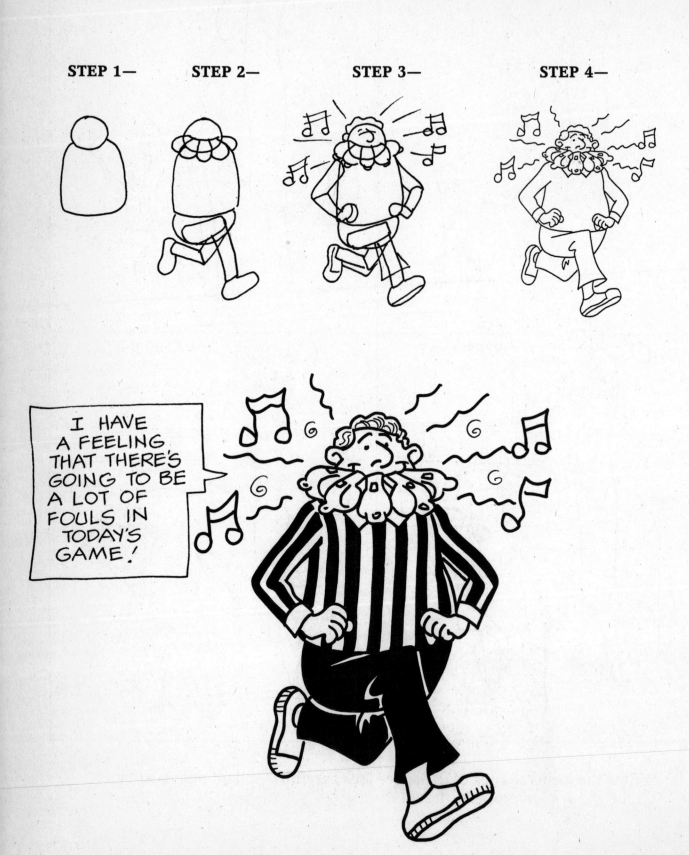

I HAVE A FEELING THAT THERE'S GOING TO BE A LOT OF FOULS IN TODAY'S GAME!

LISTEN TO THE COACH

Does the coach know best?

STEP 1—

STEP 2—

STEP 3—

STEP 4—

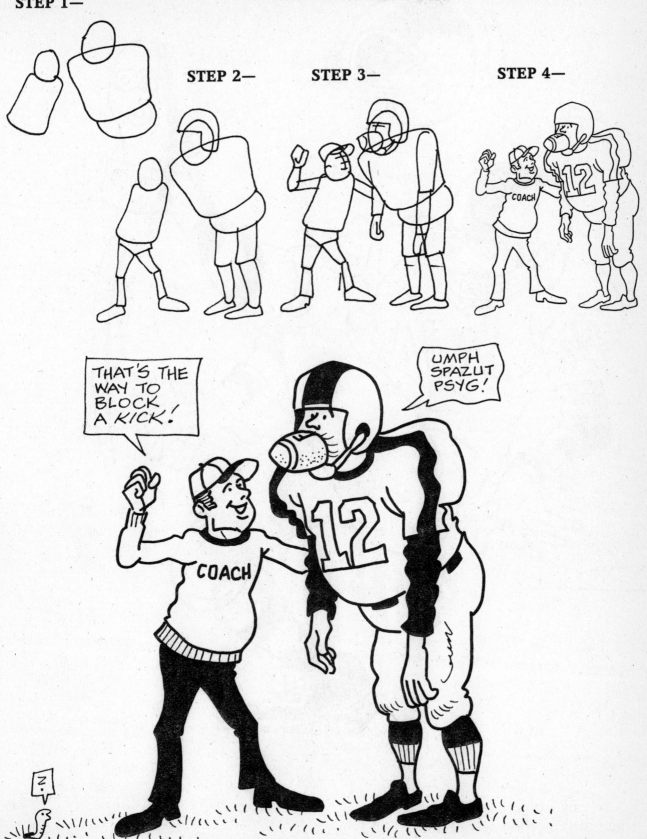

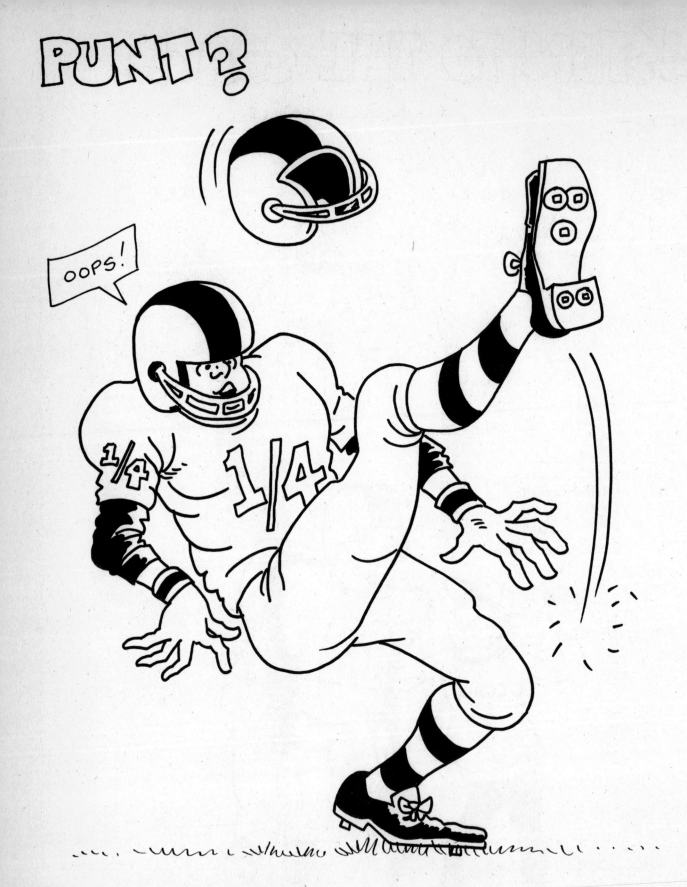

Always keep your eyes on the
ball and on the basic shapes.

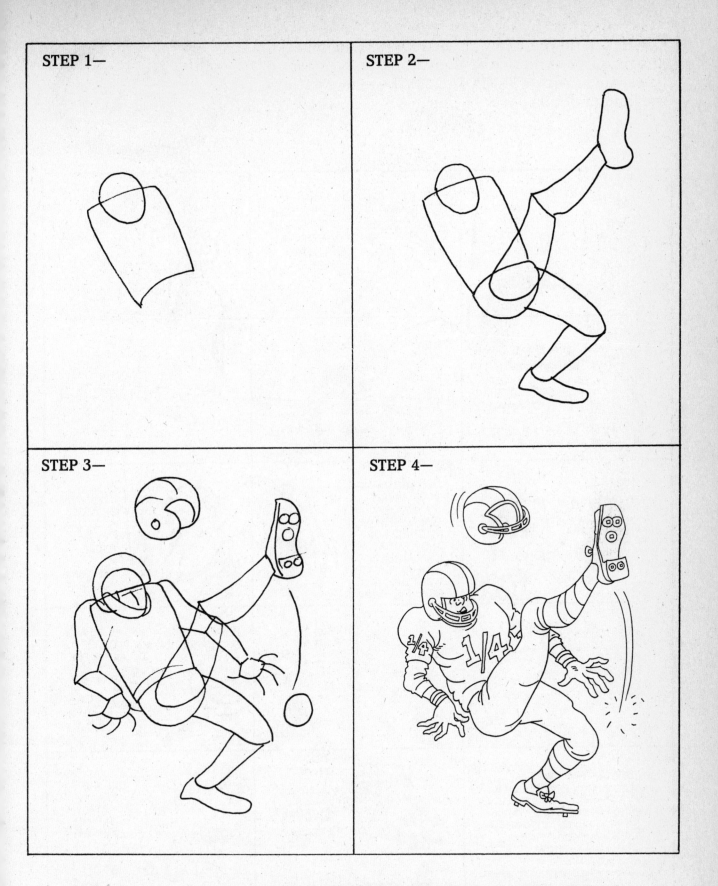

STEP 1—

STEP 2—

STEP 3—

STEP 4—

Don't forget to continue drawing the first three basic shapes lightly in pencil before drawing the finished cartoon.

How much do you know about SPORTS? Can you answer some of these questions from the popular newspaper feature TRIVIA TREAT? The answers are at the bottom of this page.

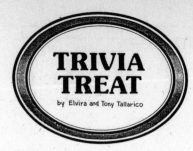

TRIVIA TREAT
by Elvira and Tony Tallarico